Painting in the
Yamato Style

Volume 10
THE HEIBONSHA SURVEY OF JAPANESE ART

For a list of the entire series see end of book

CONSULTING EDITORS

Katsuichiro Kamei, *art critic*
Seiichiro Takahashi, *Chairman, Japan Art Academy*
Ichimatsu Tanaka, *Chairman, Cultural Properties Protection Commission*

Painting in the Yamato Style

by SABURO IENAGA

translated by John M. Shields

New York · WEATHERHILL/HEIBONSHA · Tokyo

This book was originally published in Japanese by Heibonsha under the title *Yamato-e* in the Nihon no Bijutsu series.

A full glossary-index covering the entire series will be published when the series is complete.

First English Edition, 1973

Jointly published by John Weatherhill, Inc., 149 Madison Avenue, New York, New York 10016, with editorial offices at 7-6-13 Roppongi, Minato-ku, Tokyo 106, and Heibonsha, Tokyo. Copyright © 1964, 1973, by Heibonsha; all rights reserved. Printed in Japan.

Library of Congress Cataloging in Publication Data: Ienaga, Saburō, 1913– / Painting in the Yamato style. / (The Heibonsha survey of Japanese art [10]) / Translation of Yamatoe. / 1. Painting, Japanese. 2. Japan in art. I. Title. II. Series. / ND1054.5.I3413 / 759.952 / 73-3489 / ISBN 0-8348-1016-6

Contents

Painting in the
Yamato Style

CHAPTER ONE

The Origins of Yamato Painting

PERHAPS I SHOULD begin by distinguishing the word *yamato*, which is used in the name of the form of painting we shall pursue in these pages, from the place name Yamato as used to designate the ancient heartland of Japan, a district in what is now known as Nara Prefecture. Yamato is actually another name for Japan; and therefore the expression *yamato-e*, or Yamato painting, approaches the meaning of *nihon-ga* (literally, "Japanese painting"), a term used since the Meiji era (1868–1912) to designate indigenous painting as contrasted with Western-style painting. It is important to notice that until Yamato painting emerged, Japan had no particular painting genre of its own, and before the expression *yamato-e* itself came into use, there was no awareness that a purely Japanese form existed. Hence, the dawning of Yamato painting and the debut of the name must be recognized for their tremendous historical ramifications.

Yamato painting defies precise definition, but just as *nihon-ga* has now come to mean Japanese, as opposed to non-Japanese, painting (called *yoga*, or "Western painting"), so too, we may define *yamato-e* by what it is not—namely, the Chinese-style painting called *kara-e*. The two names originally went together, and I would judge that the expressions themselves surfaced in and around the same time.

During the Heian period (794–1185), pairs of contrasting expressions came into currency: there were the words *kanshi* or *kara-uta* for Chinese poetry as distinguished from the Japanese *waka* or *yamato-uta* verse forms; with flowers there were China pinks (*kara nadeshiko*) and Japanese pinks (*yamato nadeshiko*); and in learning, people spoke of *kara-zae*, denoting mastery of Chinese literature, as opposed to *yamato-damashii* or *yamato-gokoro*, denoting skill in Japanese literary pursuits. Clearly, the distinction was dawning between what was Japanese and what derived from China. Considerably later, the expression *yamato-damashii* came to mean "Japanese spirit," a phrase with strong nationalist connotations; but at the outset it meant simply the wisdom of the workaday world as distinct from knowledge acquired through studying the Chinese classics. Originally, *yamato-e* had a similarly modest meaning, not definitely designating an art form that was Japanese as much as painting of Japanese subject matter in contrast to *kara-e* and its depiction of Chinese themes. Marginal as this initial awareness of a difference was, it represented, indeed, a breakthrough of immense proportions. No more than a name first used for a difference in subject matter, it was precisely this difference from which subsequently sprang a style and ultimately a painting genre that was to be genuinely Japanese.

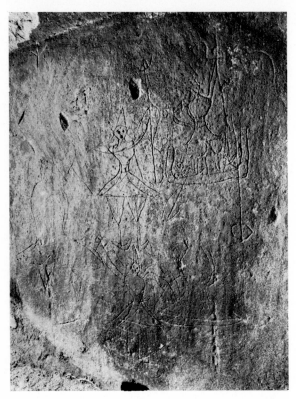

1. *Detail of human figures engraved on inner wall of tomb. Sixth century (Tumulus period). Takaida hillside tomb, Kashihara, Osaka Prefecture.*

Today, Yamato painting has broader connotations, reaching past the original usage to include an entire genre of painting that has developed under this name. Therefore, the term often designates, say, picture-scroll (*emakimono*) painting of the middle ages, even though the name *yamato-e* had passed out of use by then. It is Yamato painting in this wider sense that will be the subject of this book.

As I think will become clear once we move into a concrete study of a number of works, there was a profound connection between much Yamato painting, in its broad meaning, and Buddhism. As a matter of fact, in quite a few instances Yamato painting turns out to be Buddhist-inspired religious painting. The various elements in Buddhist painting had already jelled and the genre was given definite shape in the forms it took throughout China, India, and the lands that lay beyond, as far as

Egypt. And just as Buddhism, settling in Japan, was gradually acculturated so as finally to become Japanese Buddhism, so too, the painting techniques of the imported Buddhism now took on Japanese features and evolved into Japanese Buddhist painting. Since both the *yamato-e* and Buddhist painting styles ultimately became Japanese, as opposed to Chinese-style painting introduced from China, it might seem superfluous to distinguish them further. Yet it remains unwieldy, if not impossible, to group the two together in the same category. Buddhist painting, for all its acculturation, at least in part was bound to remain more or less faithful to the fixed mold of its mainland origins, while *yamato-e*, on the other hand, went its own way. Yamato painting simply did not follow the same line as Buddhist painting, dealing as it generally did in secular themes. Conversely, pure Buddhist painting

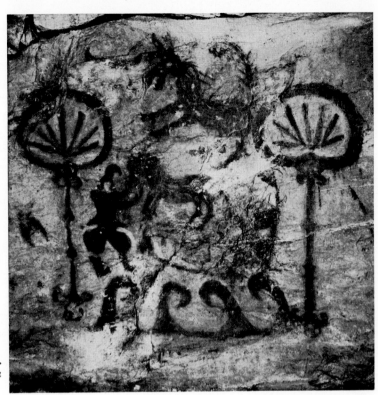

2. *Colored murals on inner wall of tomb. Sixth century (Tumulus period). Takewara Tomb. Wakamiya, Fukuoka Prefecture.*

never came to be categorized as a type of Yamato painting either, no matter how Japanized it finally became. The scope of our study, then, will be governed by traditional terminology, which largely limits *yamato-e* to what is called *sezokuga* ("secular painting," inclusive of Buddhist painting in which secular elements appear).

I would make an educated guess that the expression "Yamato painting" originated in the reign of Emperor Uda (889–97), but that actual paintings of the sort really emerged a little earlier, under Emperor Montoku (r. 850–58). I mentioned at the beginning that no genuinely Japanese genre existed until Yamato painting. But I should qualify this statement: if the facts were known, Japanese artists had long been painting to suit their own fancy in preference to taking up the Chinese style. Even the

so-called earliest man, the Cro-Magnon of the European Stone Age, left skillful cave depictions of animals and the like. Man seemingly manages to be an artist in his own right without the aid of any special lessons. In Japan, ruins and archaeological finds from the Jomon (3000 B.C. to second century B.C.), Yayoi (second century B.C. to third century A.D.), and Tumulus (third century to sixth century) periods reveal many crudely engraved pictures that resemble a childish doodling of sorts (Fig. 1). And burial mounds in Kyushu even have murals in color (Fig. 2). This color work was apparently influenced by Korean art (Fig. 3), indicating early connections with the continent, but the previous engraved pictures show no evidence of being derivative. Even the colored murals in the burial mounds evince many elements from Japanese life and so cannot be simply explained as imports. It

would not be stretching the facts, therefore, to suggest that such works are the prehistorical beginnings of *nihon-ga*—in other words, of the Yamato painting tradition.

Still, the crude, primitive quality of this age-old artwork makes it difficult to believe that the *nihon-ga* tradition grew directly out of it in any linear fashion. Japanese painting techniques were to be much more than the automatic end product of an evolution in such rudimentary art forms unaccompanied by any outside influence. The needed stimulus came in the seventh century with the systematic introduction of highly developed art forms from the mainland; Chinese-style painting techniques of the time were to provide the more immediate starting point. Although the color murals in the Japanese burial mounds deserve credit for

presenting a rich set of elements from which the later *yamato-e* could draw inspiration, the most decisive factor as *yamato-e* was in the making was obviously the Chinese painting from the seventh and eighth centuries onward—more precisely, the Chinese secular-painting style known as *kara-e*. (*Kara-e* is painting, usually by Japanese artists, after the style of T'ang [618–907] or earlier periods. The word was not used until the eighth century, though painting of the kind existed as early as the seventh century.)

KARA-E INFLUENCES Among the many cultural influences from the continent that made themselves felt in Japan in the first half of the seventh century were methods of painting with ink and pigments on silk or paper.

◁ *3. Hunting scene from a mural in the so-called Dance Tomb of the ancient Korean kingdom of Koguryo, then under Manchurian rule. Early fifth to early sixth century. Hsikang, Chian Prefecture, Kirin Province, China.*

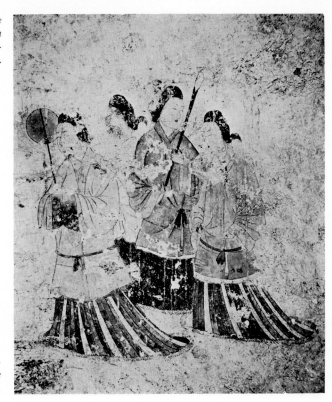

4. Polychrome mural on the west wall of the Taka-matsu-zuka burial mound, showing court ladies. Late seventh or early eighth century. Asuka, Nara Prefecture.

Since Buddhism represented the lion's share of the cultural influx during the seventh and eighth centuries, its own type of painting naturally gained the ascendancy. By the early eighth century Japan saw produced within its own shores such masterpieces as the murals in the Golden Hall of the Horyu-ji in Nara. Unfortunately, a fire ravaged these paintings in 1949 and the walls bearing the remnants were removed for preservation. Besides the Buddhist paintings, many others in Chinese style—the secular work that was afterward called *kara-e* in Japan—were imported. Copies of these were also produced in the islands, but they were few and far between.

Another example is the polychrome murals (Fig. 4) discovered in the burial mound at Takamatsu-zuka in Nara Prefecture in 1972. They date from the end of the seventh or the beginning of the eighth century. Besides the Chinese-style animal deities (the deities of the four cardinal directions) there are realistic depictions of men and women who served at the court.

The art objects that have been preserved in the Shoso-in repository, Nara, were originally things used by Emperor Shomu (r. 724–49) in his daily life and donated to Todai-ji temple in Nara after his death. As such they represent the quintessence of the imported continental culture at the Japanese court of the eighth century. The Shoso-in collection includes such items as musical instruments decorated with depictions of a game of *go* under pine trees (Fig. 6) or Tartars riding an elephant with a landscape in the background (Fig. 7), and works like *Lady Under a Tree* (Fig. 17), originally on a fold-

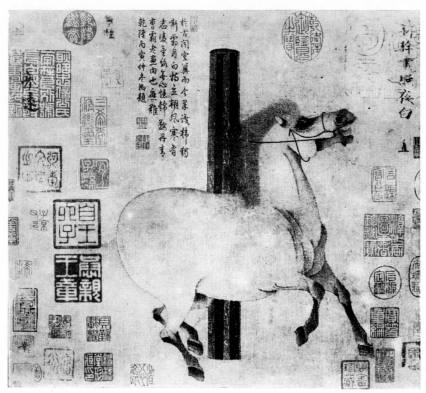

5. T'ang Horse (*Night White, the favorite steed of Emperor Hsüan Tsung*), from a scroll attributed to Han Kan. Eighth century.

ing screen, showing a Chinese-style beauty. A reading of the record of presentation of these objects to the Todai-ji tells us there were once several other screen paintings that are now lost. One showed the emperor and a multitude of officials attending a musical performance in front of the T'ang palace; another painting portrayed great figures from Chinese history, also before the palace.

Again, in the eighth and ninth centuries, portraits of Confucius or his disciples were duly hung in the Japanese court and elsewhere (Fig. 18). In the imperial school of higher learning, for instance, the training of government officials was conducted by using the Confucian classics as a text. The portraits of Confucius and his disciples were regularly enshrined for the annual festival in honor of Confucius. There were also Chinese-style landscapes (*sansuiga*), paintings of the Thirty-two Sacred Sages of China, the Seven Sages in the Bamboo Grove, horse depictions, and the like. All of this is documented, or can actually be seen in the picture scrolls of the middle ages.

If a good portion of this art very probably came direct from China, there was also some executed here in Japan but modeled on mainland counterparts; or, again, some that only borrowed Chinese subject matter. In the final analysis, however, this all amounts to *kara-e*. The horses in the horse paintings, it might be objected, also roamed Japan. Why consider them copies? The rejoinder is that horse themes were a veritable rage in Chinese art (Fig. 5) in and around T'ang; the safer course is to posit a Chinese prototype. With so little extant, however, we cannot be certain. Yet if the style and

6. *Decoration on a Chinese lute, showing a game of go beneath pine trees. Colors on leather; width, 16.7 cm. Eighth century. Shoso-in, Nara.*

composition of the screen-panel painting *Lady Under a Tree* in the Shoso-in (Fig. 17) is any indication, the patent similarity to the T'ang beauty type —obvious from a glance at Figure 19—makes it clear, at least to me, that nearly all such Japanese works were quite tied to Chinese models. As long as they were content with, or sought to copy, the painting by Chinese, Japanese people would not be likely to display any native originality.

KARA-E JAPANIZED As I mentioned before, Yamato painting introduced Japanese themes around the middle of the ninth century; and from the tenth century onward, the new form quickly caught on. Painting in Japan now opened out in a new direction, whereas so far it had moved only in the circumscribed world of

kara-e. The latter was on the decline, retaining its Chinese subject matter but becoming less and less imitative. Examples of the change in *kara-e* would be the portraits of Meng Ch'ang-chün (?–c. 279 B.C.), who appears in *Shih Chi* (Historical Records), one of the famous twenty-four histories of China written by Ssu-ma Ch'ien. Then there are the screens or panels illustrating poems from the popular *Wen Hsüan* (Literary Selections), thirty volumes of the best poems of one hundred poets, spanning over a thousand years, from c. 1030 B.C. to A.D. 557; from the *Po Shih Wen Chi* (Po Chü-i Anthology) by the famous T'ang poet of the same name (772–846); or from his *Yüeh Fu,* a collection of Chinese poetry. Po Chü-i's *Ch'ang Hen Ko* (Lasting Enmity), an epic poem about Emperor Hsüan Tsung (685–762) that romanticizes, while it in-

7. *Decoration on a* biwa *(lute), showing Tartars riding an elephant. Colors on leather; height, 40.5 cm.; width, 16.5 cm. Eighth century. Shoso-in, Nara.*

8. *Detail from the* Yomogiu *(The Palace in the Tangled* ▷ *Wood) scroll of the* Genji Monogatari Emaki *(The Tale of Genji Picture Scroll). Colors on paper; height, 21.8 cm. Early twelfth century. Tokugawa Art Museum, Nagoya.*

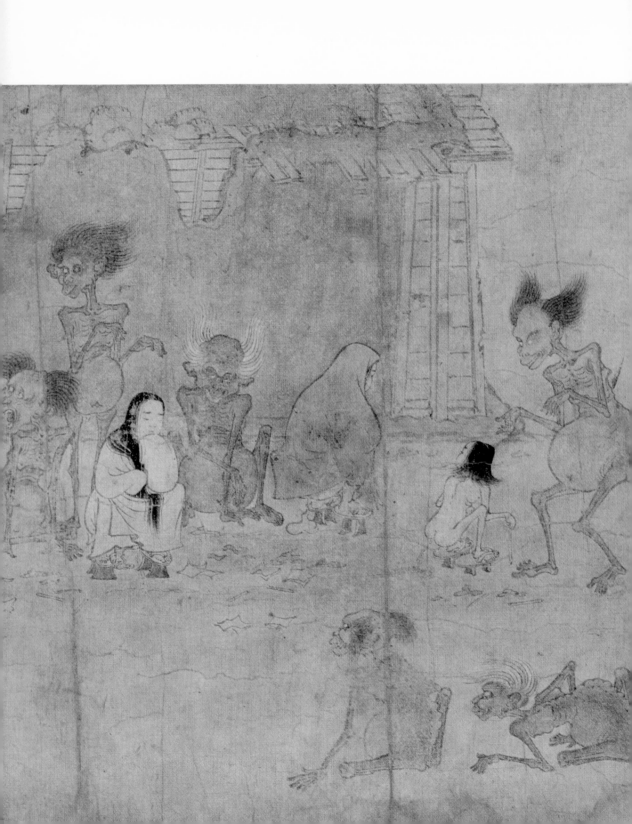

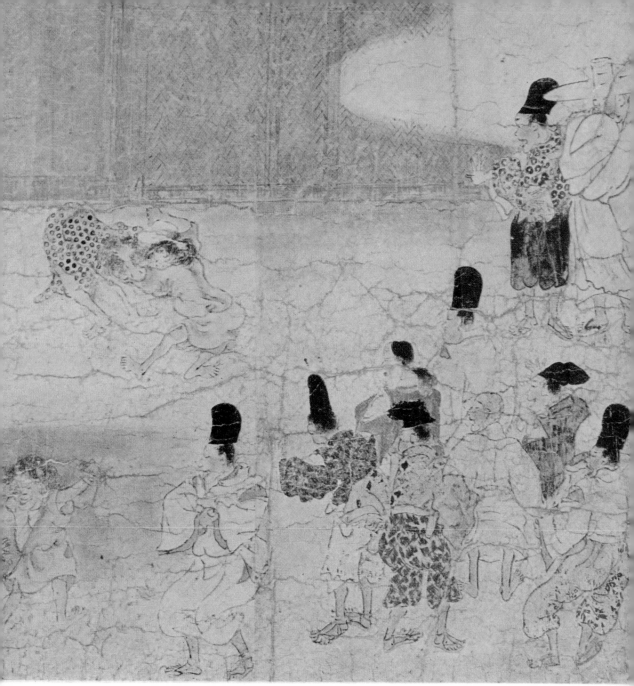

10. *Street-fighting scene from the* Ban Dainagon Emaki *(Story of the Courtier Ban Dainagon Picture Scroll). Colors on paper; height, 31.5 cm. Second half of twelfth century. Sakai Collection, Tokyo.*

◁ 9. *Excrement-eating devils from the* Gaki Zoshi *(Scroll of Hungry Ghosts), Kawamoto version. Colors on paper; height, 27.3 cm. Second half of twelfth century. Tokyo National Museum.*

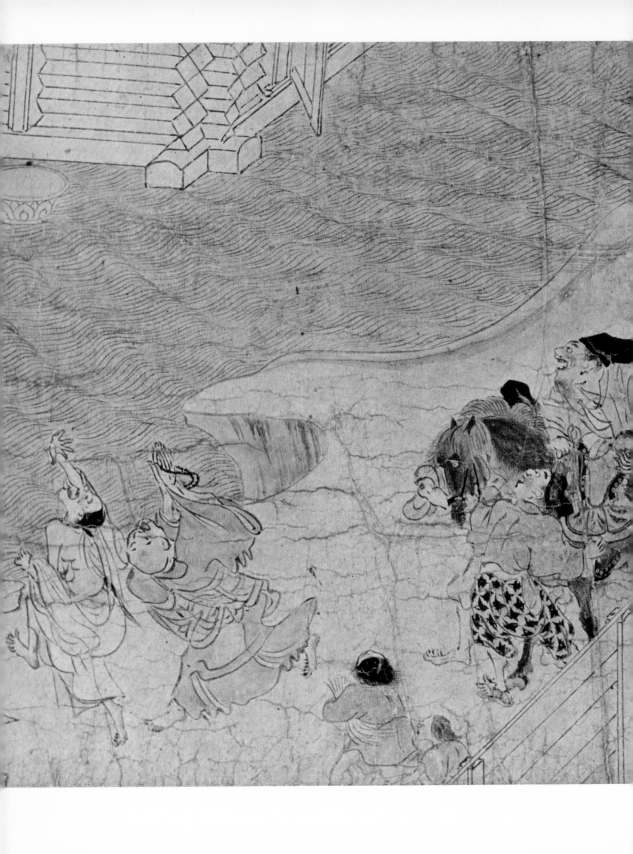

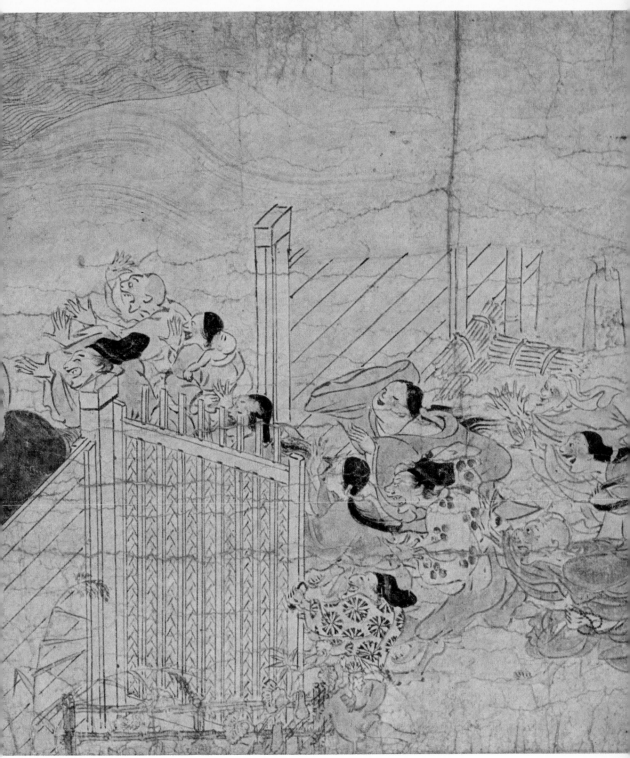

11. *The storehouse flying away. From the* Shigi-san Engi Emaki *(Legends of Shigi-san Temple Picture Scroll). Colors on paper; height, 31.5 cm. Second half of twelfth century. Chogosonshi-ji, Nara.*

12. *Frontispiece to the first chapter of the* Heike Nokyo *(Heike Dedicatory Sutra) scrolls. Colors on paper; height, 26.2 cm.; width, 24.5 cm. Dated 1164. Itsukushima Shrine, Hiroshima Prefecture.*

13. *Detail of underpainting for a sutra on fan-shaped paper. Colors on paper;* ▷ *height, 24.8 cm. Second half of twelfth century. Shitenno-ji, Osaka.*

何故慇懃稱歎方便
深難解有以言説意趣
難解脱義趣難知一切聲
聞及辟支佛所不能知所以者
何佛曾親近百千萬億無數諸佛
盡行諸佛無量道法勇猛精進名稱
普聞成就甚深未曾有法隨宜所説意趣
難解舎利弗吾從成佛已來種種因縁
種種譬喩廣演言教無數方便引導衆生
令離諸著所以者何如來方便知見波羅蜜
皆已具足舎利弗如來知見廣大深遠無量
無礙力無所畏禪定解脱三昧深入無際成就一切

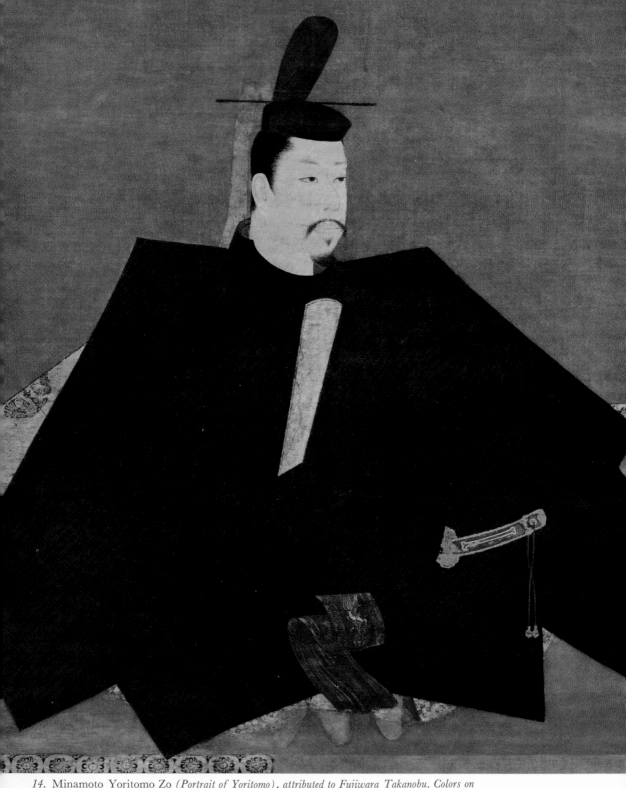

14. Minamoto Yoritomo Zo *(Portrait of Yoritomo)*, *attributed to Fujiwara Takanobu. Colors on silk; height, 139.4 cm.; width, 111.8 cm. Late twelfth to early thirteenth century. Jingo-ji, Kyoto.*

15. *Section from the* Kako Genzai Inga-kyo *(Sutra of Cause and Effect in the Past* ▷ *and Present). Colors on paper; height, 26.4 cm. About 764. Jobon Rendai-ji, Kyoto.*

日問諸綵女太子
妃相接近不綵女
言不見太子有夫
道王聞此語愁憂
樂更憎伎女而娛
之如是經時稽不接
近時王深疑恐不能
男

余時太子聞諸伎女
歌詠園林華菓茂盛
流泉清涼太子忽便
欲出遊觀即遣伎女
注白王言在宮日久
樂欲斬出園林遊戲
王聞此語心生歡喜

皆令清淨太子即往
注至王所頭面礼已
辭出而去時王即便
勅一舊臣聰明智慧
善言辯者令從太子
余時太子與諸官屬
前後導從出城東門

16. *Catchball scene decorating a sutra container* (karabitsu). *Second half of ninth century. Kyo-o-gokoku-ji (popularly known as To-ji), Kyoto. (Infrared photograph.)*

veighs against, the treachery of Lu-shan, who had the ruler's queen and mistress, Yang Kuei-fei (719–56), strangled, is another example. This was *kara-e* with a twist never seen in the country of its origins. The Japanese upper classes were captivated by the *Historical Records*, the *Po Chü-i Anthology*, and the *Literary Selections*. They longed to have the enchanting verse visualized in the medium of painting. Chinese as the materials were, the rendering was in such exquisitely Japanese taste that the result may be justly called Japanized *kara-e*. So it was that Japanese painting, as of the tenth century—both in the birth of *yamato-e* and the Japanization of the *kara-e*—ceased its role as a Chinese purveyor and, divesting itself of Sinocentric themes, became an art world unto itself.

Unfortunately, with the exception of a Chinese scene, a *kara-e* decorating a *karabitsu* (a sutra con-tainer; Fig. 16) in the To-ji temple that pre-sumably dates from the latter half of the ninth or early tenth century, no Yamato painting or *kara-e* from the transitional phase remains. This saddles the student with a problem as to exactly how Ya-mato painting evolved out of *kara-e,* for the process cannot be retraced with any surviving painting as a rule of thumb. However, a close scrutiny of the later Yamato-painting style—the landscapes, for example, and their frequent precipices with the characteristic washed-away hollows—reveals not so much realistic Japanese scenery as a close affinity to the ethereal landscape approach of the Chinese. This means that Yamato painting doubtlessly evolved from Chinese painting through *kara-e*. I remarked earlier that *yamato-e* originally meant no more than the depiction of Japanese subject matter. But these motifs were hardly viable in a style bor-

18. Koan Junen Sekiten Zu *(Festival for Confucius and Disciples in the Tenth Year of Koan), copy. Colors on paper. Original dating from about 1287, the tenth year of the Koan era.*

17 (left). Detail from Lady Under a Tree. *Screen-panel painting. Colors on paper; dimensions of entire painting: height, 136 cm.; width, 56 cm. Eighth century. Shoso-in, Nara.*

19. Detail from T"ang Beauties. *Painting.* ▷ *Colors on silk; height, 35 cm. About 700. Central Asian Museum, Delhi.*

rowed from Chinese painting, and something more suited to the purpose was inevitably sought. In this way, Japan began to develop its own distinctive approach as to what to paint, and how to go about painting it.

THE JAPANIZATION OF CONTINENTAL CULTURE

It would be well to try and catch the pulse of the times from the end of the ninth century to the tenth century, during the transition in which contentment with copying the Chinese in the *kara-e* phase gave way to the era of painting in the Yamato style. The popular mainland culture was first absorbed in about the seventh century. The intake then began to decline, after reaching a peak in the eighth century, as the cultural elements were di-

gested. Now, at last, had come the time for Japanese aspects to surface everywhere.

Of course, even though mainland culture flourished in the seventh and eighth centuries, I must qualify this statement: it was a current confined mainly to court circles, to the culturally sophisticated life within the Daidairi, or Great Enclosure, the complex of the Imperial Palace and government offices; and to the temples. That this imported culture had very little to do with the common people or even with the private lives of the nobility is plain from the dearth of Buddhist (in other words, Chinese) allusions in the *Man'yoshu*, the famous twenty-volume anthology written by poets of all classes that is therefore a precious sociocultural, as well as historical, source. It would be a great mistake to imagine the whole of Japan in the

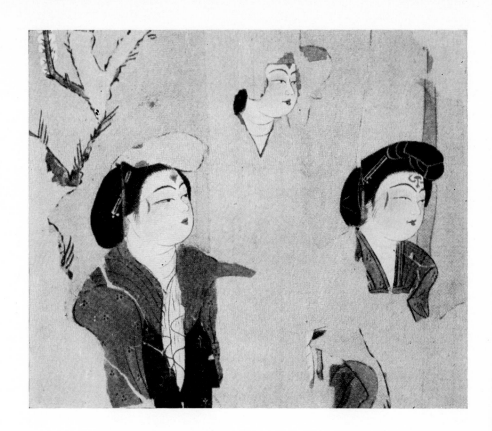

seventh and eighth centuries as saturated with an alien culture. Nevertheless, in the public domain of the privileged, highly cultured upper classes, especially in an age of creative arts, the cultural stream from the mainland clearly exerted its influence.

But once past the ninth century, we notice some interesting signs: the gradual eclipse of Japan's T'ang-modeled *ritsuryo* political structure; that is, an administration based on a penal code (*ritsu*) and a civil and administrative code (*ryo*). Even China itself began to decline. The cultural wave began to recede, influenced by various factors, leaving the climate changed. Moreover, Japanese cultural capacities had made remarkable progress during years of studying mainland arts. The feeling gradually took over that native talents were enough; that the heights were within reach without leaning on extraneous forms. This confidence, hand in hand with the general situation just mentioned, eventually culminated in the appearance of a truly Japanese culture, created by Japanese people and consonant with actual Japanese life.

Now, the writing was on the wall in the Japanese political sphere, especially. In the *ritsuryo* structure, various extralegal offices were gaining ground which had no counterpart in the original Chinese system. As examples, we find the *kurodo* (archivist in charge of confidential government dossiers in the Heian period); the *kebiishi* (police commissioners); and the *sessho* (regents) or *kampaku* (chief advisor to the emperor). Instead of looking on the proliferation of such positions as the winding down of the *ritsuryo* system, I think it should be interpreted as the inevitable remolding of the political bureau-

20. *Ancient Chinese landscape detail from the* Nü Shih Chen T'u Chüan (*Illustrated Admonitions of the Court Steward*) *picture scroll, attributed to Ku K'ai-chih. Colors on silk. Eastern Chin dynasty. Fifth century. British Museum, London.*

cracy along Japanese lines. The religious world also had a parallel. The Buddhist sects existing in Japan up until the eighth century had been little more than mirror imitations of Chinese Buddhism: Sanron-shu, one of the six sects of the Nara period, founded in 625 by the Korean monk Ekan; Hosso-shu, spread by Dosho, who had studied the doctrine under the Chinese Hsüan Tsang; and Kegon-shu, a reform sect building on the Sanron and Hosso, as preached by Shinsho, a missionary from the kingdom of Silla in Korea. But the new sects were a breed apart: Saicho (767–822), the founder of Tendai Buddhism, and Kukai (774–835), founder of the Shingon sect, both traveled to China to study Chinese Buddhism. Nevertheless, each brought back a Buddhism that was, doctrinally speaking, trimmed to his particular needs. The two

founders were worlds apart even though they studied in the same eighth-century China. In their hands, the new Tendai and Shingon sects show a separateness far beyond the earlier six Buddhist sects of Nara; and with such independent creeds as a base came the Jodo faith preached by the priest Genshin (942–1017). Jodo was the final stage—Buddhism had become Japanese.

As Buddhist thought underwent this ongoing assimilation, we see a change coming over its relations with the indigenous religion, Shintoism. During the seventh and eighth centuries, Shintoism and Buddhism had kept a safe, mutual distance. But by the mid-700s they gradually began to warm to one another, then to court affections. Their paths intertwined in the ninth century, the basic reason offered for the rapprochement being that they were, after

21. *Landscape mural on the east wall of the imperial tomb of Yung Ch'ing of the Mongolian kingdom of Liao. About 1031. Palin, Inner Mongolia.*

all, chips off the same block. The doctrine of *hon-ji-suijaku* was developed, which permitted Shintoists to believe that Buddhist deities had taken the form of Shinto deities for the salvation of the masses; or, seen from the Buddhist side, that Shinto gods were but manifestations of Buddha. The doctrinal views are said to have coalesced between the end of the ninth century and the beginning of the tenth—just about the time, interestingly enough, when Yamato painting appeared on the horizon.

DEBUT OF WRITING A similar phenomenon
IN JAPAN took place with writing,
 which also has an inti-
mate connection with painting. Just as full-fledged painting techniques did not exist in Japan until those of the mainland were introduced, no charac-

ters existed in the islands until the *kanji* of China were imported. Again, in the same way that the Japanese were content for a time with *kara-e*, they also made do temporarily with Chinese characters, having no other means of writing.

The *kanji*, however, were characters designed to express Chinese in written form. Chinese is semantically structured along quite different lines from the Japanese language, and each character is used to express one very definite meaning. Our forebears therefore found it impossible to adopt the characters straightaway as a Japanese writing vehicle. But when sheer necessity forced them to use this script, people first had to strip away the original meaning attached to the Chinese characters so as to obtain a set of phonetic symbols, or *man'yo-gana*, as they are called. In other words, through using

22. *Landscape detail. Ink on hemp cloth; dimensions of entire painting: height, 58 cm.; width, 176 cm. Eighth century. Shoso-in, Nara.*

Chinese characters phonetically, i.e., reading Chinese writing with Japanese pronunciation, people could manage to communicate on paper. This may appear to some a trivial accomplishment, but I find it a marvelous piece of ingenuity. But since representing Japanese syllables with the many-stroked characters was cumbersome, the Japanese contrived a reduction of the *man'yo-gana* script into a greatly simplified system, the *katakana* syllabary; and again, the creation of yet another streamlined set of cursive characters that corresponds to our present-day *hiragana*. These new, easy-to-write forms were literally custom-made to serve as phonetic symbols in Japanese written expression. True, a similar streamlining of characters was not altogether unknown in China; but here the matrix characters are kept, while form and function are completely recast into another language. They are now utterly Japanese. When this written form finally jelled is difficult to say. Generally, it is thought to have occurred in or around the middle of the ninth century—again, just about the time Yamato painting emerged. The origins of both *kana* and Yamato painting are strikingly the same: both came from China, and both shed their beginnings for a vastly different form of their own making.

I have dwelt at some length on these subjects (which are perhaps not directly relevant to Yamato painting) because I think they are essential to an understanding of the conditions prevailing when Yamato painting, with all its historical significance,

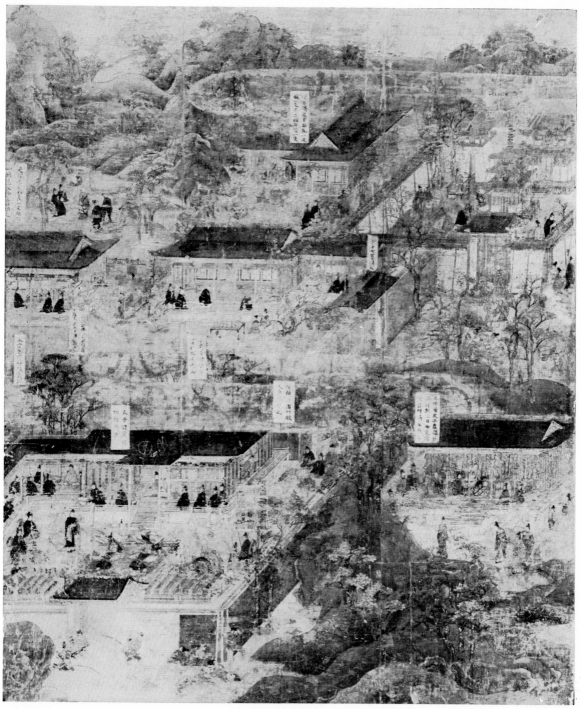

23. *Detail from the* Shotoku Taishi Eden *(Pictorial Biography of Shotoku Taishi) folding screens. Colors on silk; dimensions of single panel: height, 181.3 cm.; width, 272 cm. Dated 1069. Tokyo National Museum.*

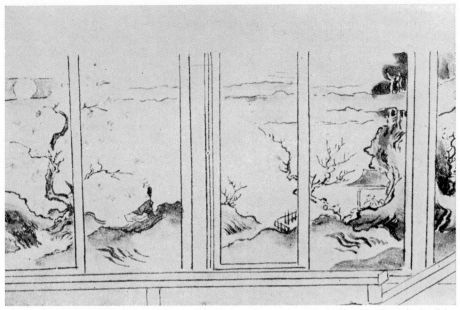

24. *Four-seasons paintings on door panels (*shoji*) from the* Saigyo Hoshi Gyojo *(Saigyo's Deeds) picture scroll, by Tawaraya Sotatsu. Colors on paper; height, 32.6 cm. Dated 1630. Watanabe Collection, Tokyo.*

actually appeared. The Buddhism brought in from abroad was completely acculturated and eventually became the starting point for launching original Japanese Buddhist sects such as the Jodo-shu, Jodo Shin-shu, Ji-shu, and Nichiren-shu. The full development of *kana* later led to the flourishing *kana* arts during the late Heian period, arts which were to spur the muses continually in so many cultural areas of Japanese demarcation. In the same fashion, the birth of Yamato painting was the first historic step prefiguring beautiful fulfillment in the rich *nihon-ga* to come. This, then, is the broad picture of how painting in the Yamato style began. Our next task is to examine it at close range, then follow it through the transitions it saw with the passing of time.

25. *Detail of landscape painting on a door of the Phoenix Hall. An example* ▷ *of Heian-period four-seasons painting. Colors on wood; dimensions of entire painting: height, 373.5 cm.; width, 134.1 cm. Dated 1053. Byodo-in, Uji, Kyoto Prefecture.*

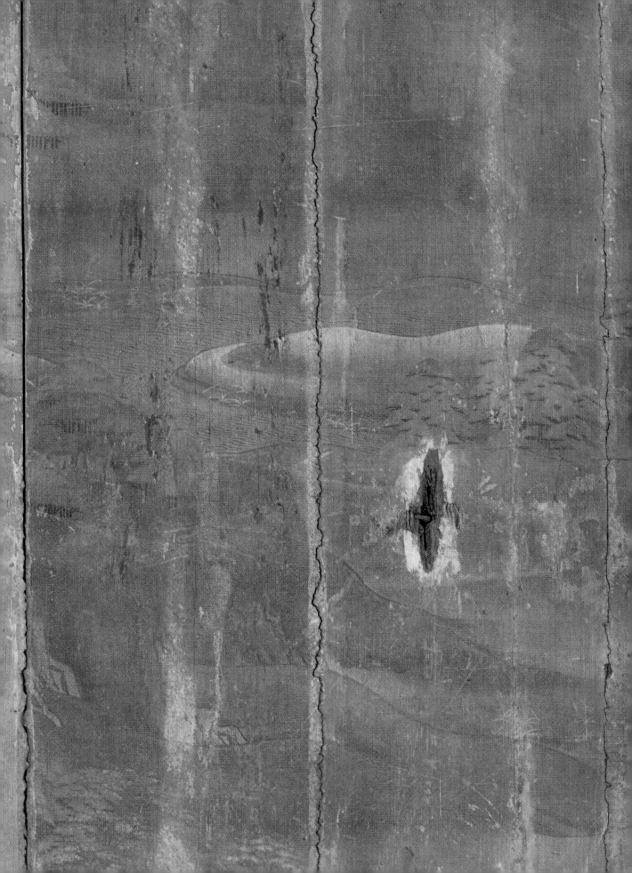

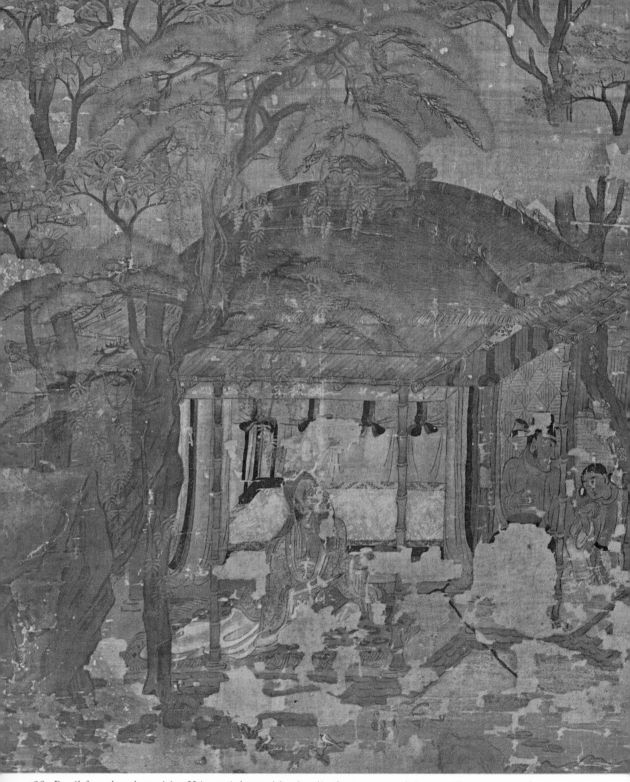

26. Detail from the only surviving Heian-period senzui byobu (landscape screen). Colors on silk; dimensions of single panel: height, 146.1 cm.; width, 42.6 cm. Second half of eleventh century. Kyoto National Museum.

27. Detail from one of the few surviving senzui byobu (landscape screens) of the four-seasons type. Colors on ▷ silk; dimensions of single panel: height, 110.8 cm.; width, 37.4 cm. About thirteenth century. Jingo-ji, Kyoto.

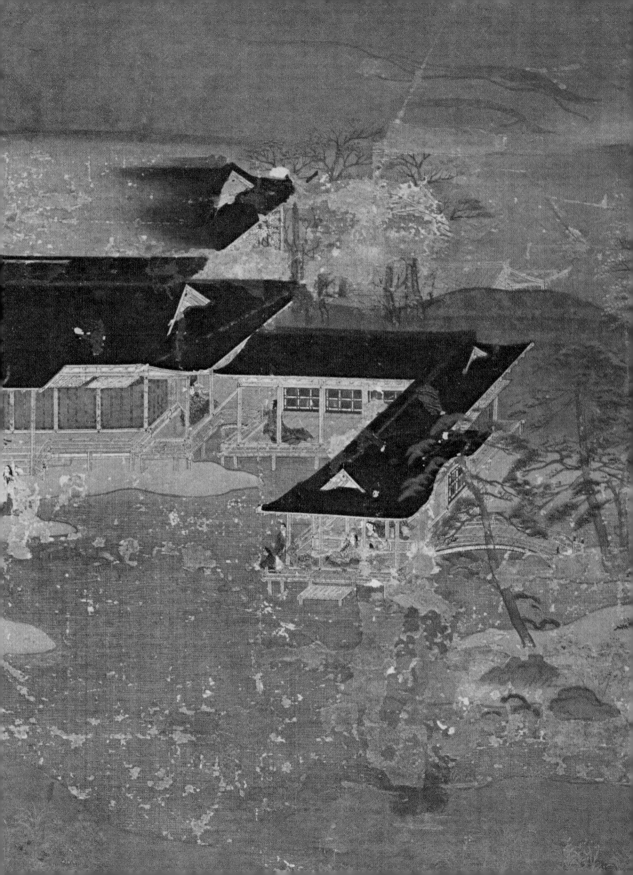

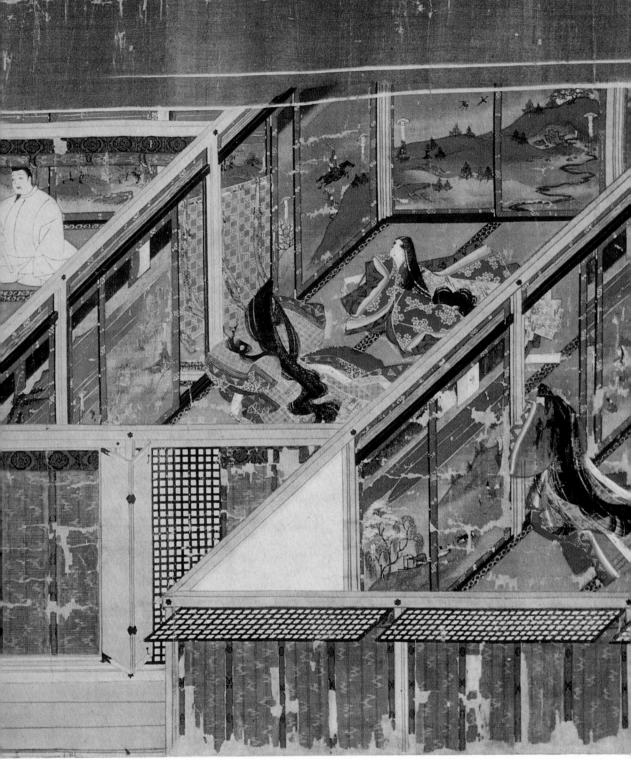

28. Section from the Kasuga Gongen Kenki *(The Kasuga Gongen Miracles)* picture scroll, by Takashina Takakane. An example of shiki-e *(four-seasons painting)* on sliding panels in a Heian-period interior. Colors on silk; height, 41.2 cm. Dated 1309. Imperial Household Collection.

CHAPTER TWO

Yamato Painting During the Heian Period

WITH THE VAST CHANGES in our life style since World War II and the tight housing situation, not every Japanese home has retained rooms with a tokonoma (the decorative alcove for display of a *kakejiku,* or hanging scroll, along with a flower arrangement or an *objet d'art*); but most families have managed to have one room with it. Moreover, a longstanding tradition, even among persons without any particular painting preference, sees that there is at least a scroll hanging there. This appreciation of painting in scroll form in the midst of modern life, however, is not all that old a custom. Needless to say, before the origin of the tokonoma in the middle ages, there was a time when scrolls were enjoyed apart from it. In the Heian period (794–1185), for example, emerging Yamato painting was appreciated in a very different way.

Yamato painting in picture-scroll (*emakimono*) form has become quite familiar these days from visits to museums or exhibitions of ancient art. (The *emakimono,* or just *emaki,* is an illustrated horizontal scroll, generally about thirty to fifty centimenters in height and of indefinite length, designed to be held and unrolled by hand—the most popular form of Japanese "book" from the tenth to the nineteenth century.) In fact, many people think of Yamato painting as the kind of illustration found in picture scrolls. It is true that the scroll, as I will

discuss below in some detail, was an important medium for Yamato painting. But at the start, the Yamato form developed on larger surfaces, such as screens or panels. Even today, when one visits old temples in Kyoto, one can see many large *fusuma* (opaque sliding panels) paintings by the famous Kano school, or by Maruyama Okyo* (1733–95), who beautifully blended East and West. The mere mention of *shoheiga* (panel and screen painting) in Japan immediately calls to mind the names of the great painting schools. These famous schools, however, really represented only the aesthetic splintering which painting in the Yamato tradition later underwent. In the Heian period, Yamato painting had the screen and panel mediums nearly all to itself, and these were produced and painted in great numbers.

The reason why so few of these screen or panel paintings remain, or why the scroll came to be the representative of *yamato-e,* is extremely simple when one reflects that no architectural structure from the Heian period survives. Panels called *shoji* and decorated with paintings formed an actual part of structures. (In modern Japanese, *shoji* refers to

*The names of all premodern Japanese in this book are given, as in this case, in Japanese style (surname first); those of all modern (post-1868) Japanese are given in Western style (surname last).

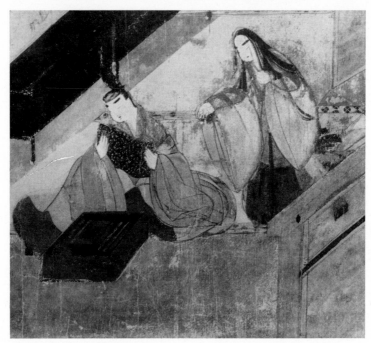

29. *Section from the* Yugiri *scroll of the* Genji Monogatari Emaki *(The Tale of Genji Picture Scroll). Colors on paper; height, 21.8 cm. Early twelfth century. Goto Art Museum, Tokyo.*

sliding partitions consisting of a wooden frame covered with translucent paper. Formerly, however, it meant "partition" and referred principally to *fusuma,* but included also free-standing single-panel screens.) As far as screens are concerned, while not permanently attached to anything in the building, they were certainly inseparable companion furnishings. Time and time again fires ravaged the emperor's household or residences of the nobles, thereby robbing posterity of nearly all the screens and panel works therein. Scrolls escaped a similar fate because they could be readily rolled up and salvaged from a blaze. Then, too, these picture scrolls could be reproduced more easily. This explains why they survive in such abundance today. (Nevertheless, the *emakimono* extant usually date from the Kamakura period [1185–1336] or after; no scroll survives from before the end of the elev-

enth century. The majority of Kamakura-period and later scrolls are inextricably bound up with the history of a local shrine or temple. Kept away carefully in their repositories, far from the fires that often swept the capital, these scrolls have survived remarkably well.)

With history so unkind, it is impossible to estimate the actual number of panel and screen paintings produced on the basis of a paltry few extant works; and to chart a history of Japanese painting using only remaining examples as a compass would be equally disastrous. A good history of classical painting, especially an accurate history of secular painting for the period, requires probing historical materials for countless works of which there is otherwise scarcely a trace. Then, by theoretical reconstruction, one tries to get back to the actual situation surrounding secular work in ancient

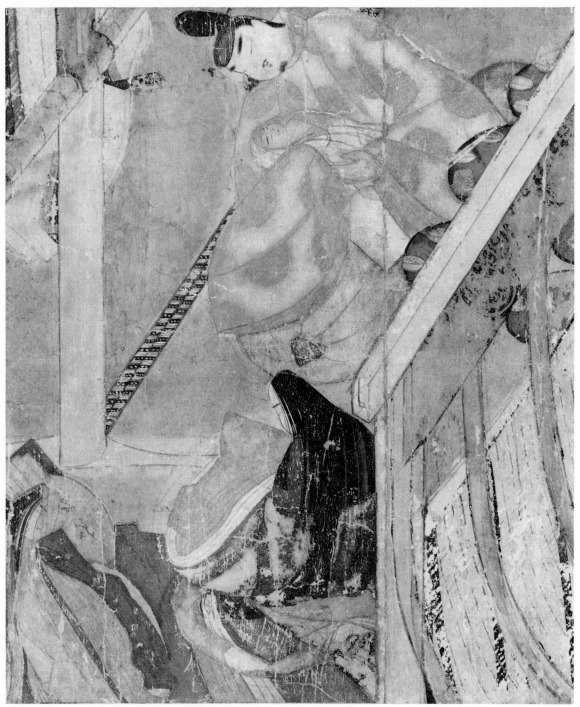

30. Section from the Kashiwagi *scroll of the* Genji Monogatari Emaki *(The Tale of Genji Picture Scroll). Colors on paper; height, 21.8 cm. Early twelfth century. Tokugawa Art Museum, Nagoya.*

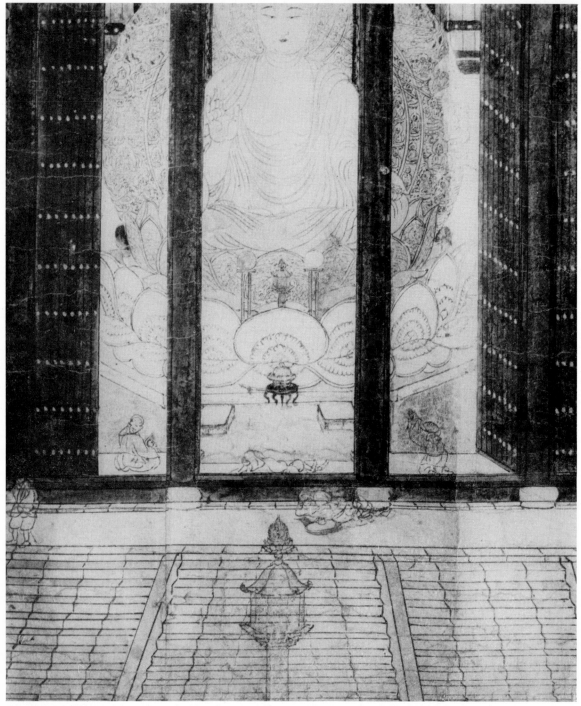

31. Todai-ji Daibutsu-den *(Great Buddha Hall of Todai-ji) section from the* Amagimi *(Noble Nun)* scroll of the Shigi-san Engi Emaki *(Legends of Shigi-san Temple Picture Scroll). Colors on paper; height, 31.5 cm. Second half of twelfth century. Chogosonshi-ji, Nara.*

32. *Section from the* Amagimi *(Noble Nun)* scroll of the Shigi-san Engi Emaki *(Legends of Shigi-san Temple Picture Scroll).* *Colors on paper; height, 31.5 cm. Second half of twelfth century. Chogosonshi-ji, Nara.*

times. Next, juxtaposing this with the extant paintings, whatever overall picture is possible is pieced together. The process differs tremendously from assembling a history of literary arts, where, with only extant works, a fair picture results. (A history of painting that begins with the middle ages is not so difficult, either, using only extant art. The case of ancient secular painting is quite special.)

What explains the proliferation of Yamato painting on screens and panels during the Heian period? It was simply an art that was part and parcel of the lives of the people by whom it was appreciated. Both the content of the paintings and their external form had become inseparable from a certain way of life. And the profusion of screens and panels with paintings in Heian reflects their having become an essential part of the life of the nobility. The point is

easier understood when one realizes that residences of the upper classes were not broken up into different rooms with permanent walls, like houses in China or Europe. The Japanese house was essentially an open structure; hardly any partitions were permanent. Instead, to divide up a space into rooms, each for a given purpose, panels which easily open or could be removed, and portable screens, quickly folded up at a moment's notice, were employed. Partitioning was a matter of temporary need. As a scholar of architectural history once remarked of the past: "It was just like having a Kabuki stage: the big props and the little props had to be arranged for each living situation." Panels and screens were the indispensable "props" in Heian times. The aristocracy who used them, however, were eminently aesthetic people. Not content with what would be only functional, they

33. *Section from the* Ban Dainagon Emaki *(Story of the Courtier Ban Dainagon Picture Scroll). Colors on paper; height, 31.5 cm. Second half of twelfth century. Sakai Collection, Tokyo.*

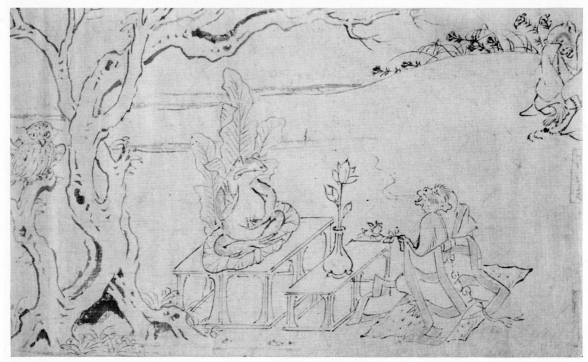

34. *Section from the* Animal Scroll *of the* Choju Jimbutsu Giga *(Scroll of Frolicking Animals and People), attributed to Toba Sojo (Kakuyu). Ink on paper; height, 31.8 cm. First half of twelfth century. Kozan-ji, Kyoto.*

sought to have exquisite paintings decorating the surfaces so that their surroundings would be a source of enjoyment for everyone from morning till night. Just as later generations have derived daily pleasure from scroll paintings hung in a tokonoma, Heian nobility had beautiful screen or panel paintings as constant household companions. A look at Figure 28, a segment from the famous *Kasuga Gongen Kenki* (The Kasuga Gongen Miracles;

donated in 1309 to the Kasuga Shrine in Nara by Saionji Kimihira, minister of the left), makes us green with envy: for the Heian-period gentility, life went on amid a beautiful, museumlike atmosphere of exquisite screen and panel paintings. Since there were so many screen and panel paintings in the Heian period, it will be suitable for us to begin our discussion of the subject matter of *yamato-e* with these.

35. *Section from the* Animal Scroll *of the* Choju Jimbutsu Giga ▷ *(Scroll of Frolicking Animals and People), attributed to Toba Sojo (Kakuyu). Ink on paper; height, 31.8 cm. First half of twelfth century. Kozan-ji, Kyoto.*

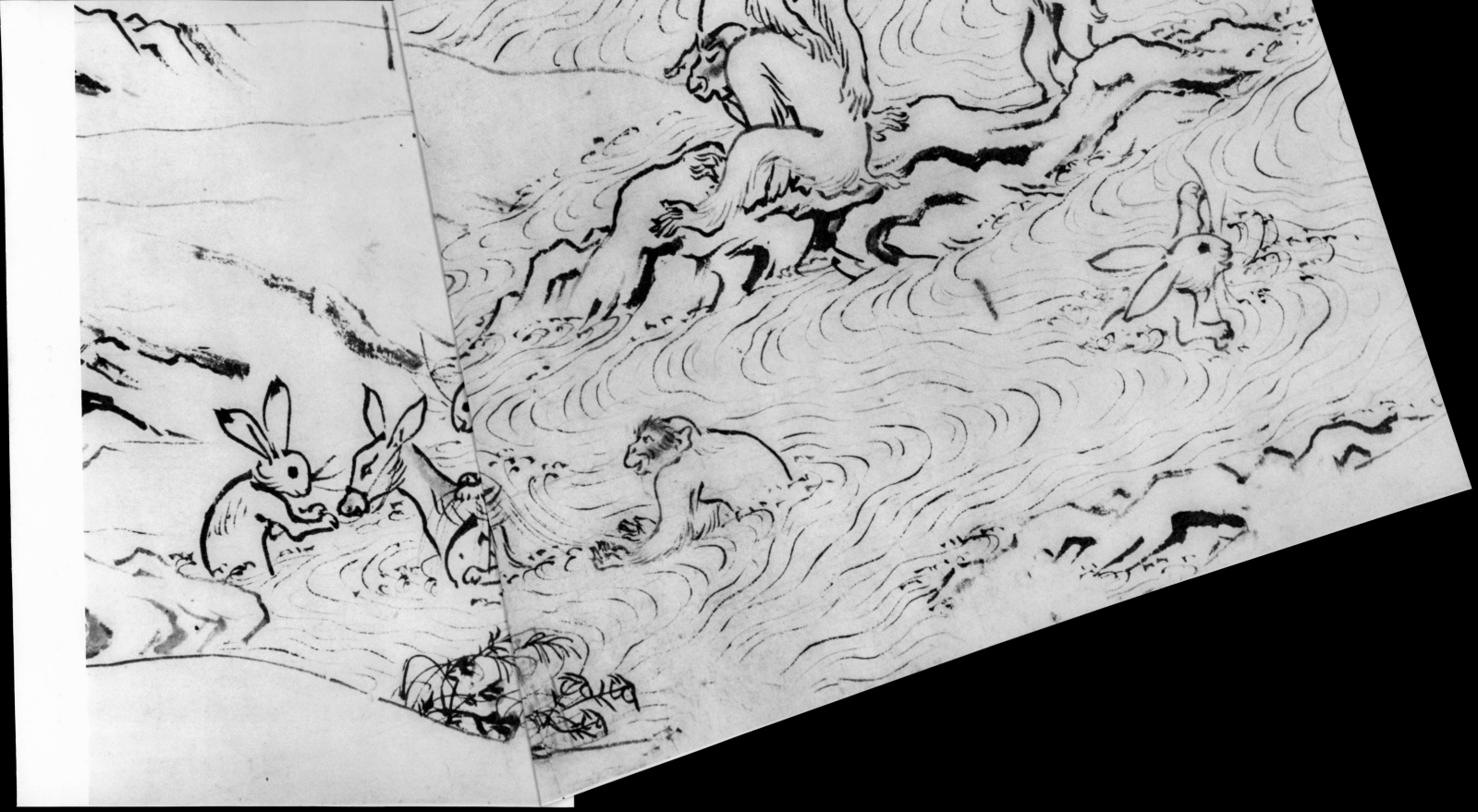

Four-Seasons Painting

IN SCREEN AND PANEL paintings a distinction is drawn between the kind used in everyday life and the kind painted for special occasions. Those painted to celebrate persons of rank reaching the ages of forty (the normal life span in Heian times), sixty, and seventy, or for the weddings of the children of the aristocracy, are examples of the latter. Again, there was the *daijoe* (the great thanksgiving service after enthronement) ceremony, held for each new emperor, followed by a court banquet (*sechie*), for which a special commemorative screen was painted. Yamato painting in all these falls roughly into two categories as to theme. First, there are the *shiki-e* (four-seasons painting) and the *tsukinami-e* (literally, "monthly-events painting"); and then there is what is known as *meisho-e* (literally, "famous-place painting"). The expression *meisho-e* corresponds to "landscape painting" in current terminology, but there is no modern equivalent for *shiki-e*. Since it treats of natural features or scenery of the four seasons, I once ventured to call it "seasonal-things painting" (*keibutsuga*) in distinction to landscape painting (*fukeiga*). Basically, the subject matter of the *shiki-e* and *meisho-e* comes down to the same elements, so in the end the distinction is purely nominal: there is really only one category, that of the *shiki-e*. Be that as it may, for convenience' sake, let us begin with the *shiki-e*.

Shiki-e is a set of paintings on panels or screens that shows the changing seasons. Several paintings of "seasonal things," or scenes from the twelve months, are brought together to form a set. The name *tsukinami-e* was used when scenes representative of the seasons in terms of each month made up the set. Chinese painting had a somewhat similar feeling for nature and the seasons, as seen in its landscape painting or the *kachoga* (bird-and-flower painting). But there is no express theme of the change of seasons such as we find in *shiki-e*. This is unique to Japan, places it in a category all by itself, and proves beyond a shadow of doubt that this kind of Yamato painting is absolutely Japanese and not a Chinese copy. It also indicates that the appearance of *shiki-e* coincided with that of *yamato-e*. My earlier remark—that Yamato painting originated in the reign of Emperor Montoku, about the middle of the ninth century—has its basis here. Historical sources substantiate that at just about that time there were paintings with four-seasons themes.

THE SEASONS IN JAPAN A clear change of the seasons is a special characteristic of the climate in the Japanese archipelago. The weather elsewhere may be monotonous all the year round; and life in the warmer climates, the Asian continent included, does not have Japan's delicate seasonal variation. Our islands have subarctic and subtropic zones at either end and are bounded by the Japan Sea on one side and the Pacific Ocean on the other. They are constantly buffeted by wind, rain, or snow. A glance at the ever-shifting skies overhead, a gaze at the endless

36. *Section from the* Minori *(The Law) scroll of the* Genji Monogatari Emaki *(The Tale of Genji Picture Scroll). Colors on paper; height, 21.8 cm. Early twelfth century. Goto Art Museum, Tokyo.*

changes on the ground, makes one keenly aware of the seasons in their restless cycle. It is difficult to imagine another place in the world where the seasons have meant so much to a nation's art. We come across an ode to July among the folk ballads in the oldest collection of Chinese poems set to song, the classic *Shih Ching* (Book of Odes); and there are seasonal themes, too, in the work of the great fifth-century Hindu poet and dramatist, Kalidasa, or in the modern poetry of the nature-loving Englishman, Francis Thompson. The fascination with seasons is surely not a phenomenon limited to Japan, although I would be ill-equipped to make definite comparisons with the art of other countries. I think it is rare, though, to find another land like Japan whose art, both in scope and depth, is so wholly caught up in the cycle of the seasons.

The most notable example is the haiku. There are modern haiku that contain not a single trace of the seasons; but traditionally, haiku—originally called *haikai*—without a reference to a season are unthinkable. Or again, there is our "seasonal" vocabulary: in a haiku, the word used for "frog" is *kawazu*. It designates the animal but, in addition, denotes springtime as well. There would seem to be few art forms in other countries that have this kind of convention.

At the risk of prolixity, I might add that this allusion to the seasons did not begin with the *haikai* either. In the *renga* also, the linked verse that preceded the *haikai*, reference to a "seasonal thing" was *de rigueur;* and even before the *renga* there was 31-syllable *waka* verse, often grouped under seasonal headings, and surely existing even in Heian

times. However, *waka* poetry and screen or panel painting formed an indivisible union: which was the basis for the other is unknown. (I will come back to this later.) From the viewpoint of place awarded the seasons, the panel and screen art would seem to have the edge. In any event, the point that deserves stress here, I believe, is that this feeling for the seasons which informs so much Japanese art must be seen as central to, and the principle constituent of, painting in the Yamato style.

There is another underlying reason for the importance the seasons have in Yamato painting. I have already mentioned the sharp seasonal transitions that mark the Japanese climate in general. Another factor exerting a special influence was surely the particular locale of the culture that gave birth to Yamato painting. It was not Heijo-kyo (the capital from 710 to 784; now called Nara), in a relatively dry region, but Heian-kyo (now called Kyoto), on the humid plain of Yamashiro, to which the capital was subsequently moved in 794, that provided the environment. It was at Yamashiro that the courtiers could feel the throb of the seasons more intensely. The beautiful lines quoted by Sakutaro Fujioka (1870–1910) in the *Kokubungaku Zenshi Heiancho-hen* (Complete History of Japanese Literature: The Heian Period) describes this ambience:

"Few lands enjoy our clear division of the seasons. In Japan the transition from one season to the next is vividly felt. Though almost devoid of blossoms and autumn's tinted leaves, the undulating line of our seacoasts is striking. Yet this beauty cannot begin to match that of the loveliness the four seasons lend to the capital. There, no sooner has spring arrived than the surrounding hills are draped in veils of thick mist, and the sky, and the water too, reveals hues different from those of yesterday. The gathering of the seven herbs and branches of the young pine signify the New Year season. The scattering of plum blossoms and the cry of the aging bush warbler—these tell of the willow's greening, the crimsoning of the peach, the glad tidings of flowers everywhere. The greening of the land is like a dream. Just when the brierbell

and mandarin orange blossom have gone, the cuckoo's voice is stilled—prudent bird, he marks the season's turning! In May the thin rain drips ceaselessly from the eaves; official business and temple-going slow to a trickle. And when the rains depart, the fierce heat of summer soon closes round. But its time, too, is soon over, for when the rites of summer are complete, the heat soon passes. Cool breezes blow then and the falling of the first leaves is a sign of autumn, the time when the wild grasses, the cries of insects, the moon's cold unmisted stare —all things—reveal the pathos of the season. The darkening colors of the leaves spell fall's farewell, the cold wind whines in the dry branches, the frost of winter stings the skin; and then the gentle snow comes to comfort us as another year draws swiftly to its close."

Small wonder that a setting like this, with its unending cycle of seasons, each marking the capital so indelibly, would produce the art form of *tsuki-nami-e*.

SHIKI-E THEMES *Shiki-e* in the Yamato style, growing out of this background as it did, used the subject matter given in the following list under seasonal headings.

SPRING. *Ganjitsu:* New Year's Day and the life and events centering around it. *Wakana tsumi:* the gathering of young wild shoots at the beginning of the year. *Nenohi no komatsu hiki:* the uprooting of young pines as the year begins; an amusement associated with long life and good fortune. *Ume:* plum blossoms; the early sign of spring. *Kasumi:* morning and evening mists that betoken the change from winter to spring. *Uguisu:* nightingale, whose call is associated with spring's arrival. *Kiji:* the Japanese pheasant; its color is dark green and it is often alluded to in literature. *Yanagi:* the greening willows of spring. *Inari mode:* paying respects at a shrine during Inari Festival. *Haru no no-asobi:* enjoying spring fields. *Kaeru kari:* the geese going back in spring. *Momo:* peach blossoms. *Sakura:* cherry blossoms. *Rakka:* blossoms falling (like spring snow). *Koyumi:* small bows used at shrines in spring. *Yana:* fish traps. *Haru no ta:*

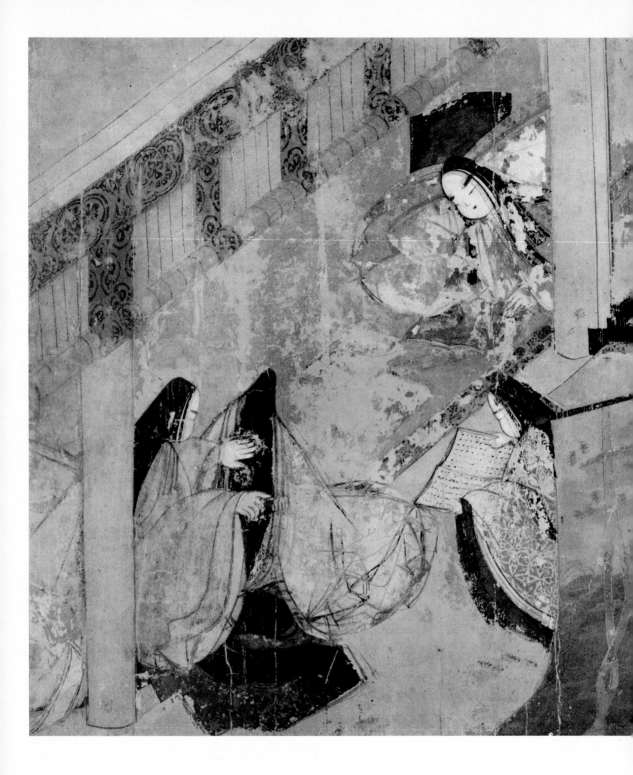

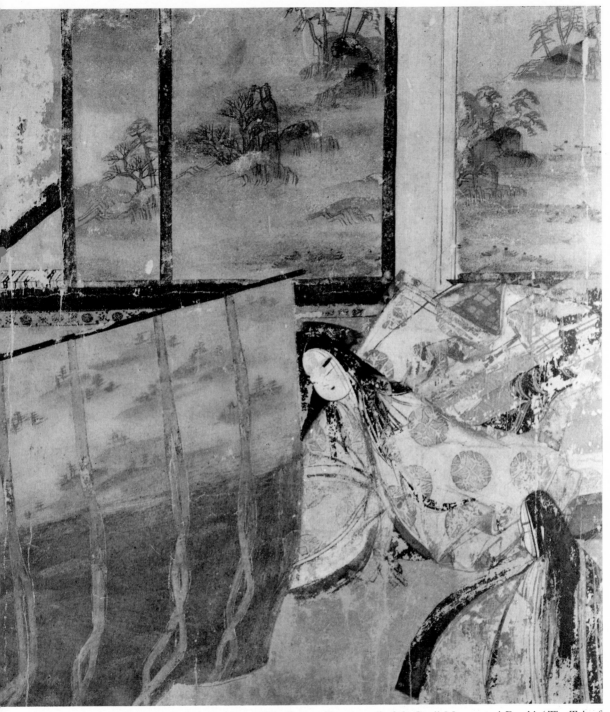

37. *Section from the Azumaya (The Eastern House) scroll of the* Genji Monogatari Emaki *(The Tale of Genji Picture Scroll). Colors on paper; height, 21.8 cm. Early twelfth century. Tokugawa Art Museum, Nagoya.*

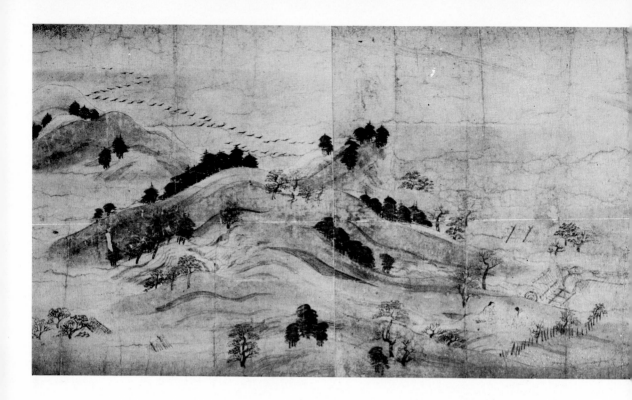

paddies before rice planting. *Yamabuki:* the yellow flowers of a bush; sometimes called "yellow rose" in English. *Kakitsubata:* purple irises. *Fuji:* wisteria. *Haru no umi:* calm spring seas. *Oborozuki:* the hazy vernal moon.

SUMMER. *Kamo mode:* paying respects at the Kamo Shrine in Kyoto (often in conjunction with the April Festival). *O-miwa matsuri:* the great festival of the oldest shrine in the world (near Nara). *Uzuki-no-kami matsuri:* April Shinto festivals. *Unohana:* Japanese sunflowers (often used for hedges and garden borders) that bloom in May. *Natsu kusa:* the various grasses of summer; these often appear in literature. *Ayame:* the calamus, or sweet rush; now called *shobu;* associated with the Boys' Festival. *Hachisu no ike:* ponds with lotuses in bloom. *Tokonatsu:* wild pinks named Everlasting Summer.

Hototogisu: cuckoo. *Tachibana:* the fragrant mandarin trees. *Tomoshi:* the torches used to "shine" mountain animals at night during summer hunting. *Samidare:* the rainy season in May, also called *baiu. Asagao:* morning glories that spell the advent of summer. *Kagaribi:* fires to attract prey or ward off beasts. *Taki:* waterfalls. *Izumi:* springs. *I:* wells. *Minatsuki-barae:* the June 30 exorcism rites at summer festivals. *Natsu kagura:* Shinto dance and music performance at time of summer purification. *Suzumi:* enjoying the evening cool in summer.

AUTUMN. *Bon:* the Feast of Lanterns on July 15. *Koma hiki:* presentation of fine horses to the ruling class at court. *Koma mukae:* picking up horses suitable for the emperor's stables in Omi Province and taking them to the capital. *Tsuki:* the autumn moon and the events that were associated with it.

38. *Section from the* Engi Kaji *(Engi Incantation) scroll of the* Shigi-san Engi Emaki *(Legends of Shigi-san Temple Picture Scroll). Colors on paper; height, 31.5 cm. Second half of twelfth century. Chogosonshi-ji, Nara.*

Shiga no yamagoe: the scenic crossing over the mountains from Omi (Lake Biwa side) to Kyoto. *Kinuta:* washing clothes by the riverside and beating them on a board; the sound somehow became associated with autumn. *Tsuyu:* autumn dew. *Senzai hori:* ritual planting of trees, shrubs, and grasses in autumn. *Senzai awase:* poem contest at ritual planting in autumn. *Shika:* deer. *Ko-taka-gari:* hunt with small falcons. *Wasure-gusa:* forget-me-nots. *No no hanami:* enjoying autumn fields. *Kiku:* chrysanthemums and connected festival on September 9. *Kari:* geese. *Kiri:* autumn mists. *Momiji:* scarlet maple leaves. *Ochiba:* falling leaves. *Aki no ta:* stubbled autumn paddies.

WINTER. *Shigure:* intermittent rains in early winter. *Rinji no matsuri:* a special festival held at the Kamo Shrine, Kyoto. *Kagura:* performance of sacred Shinto music and dance. *No no miyuki:* emperor's visit to a falcon hunt. *O-taka-gari:* hunt with big falcons. *Shimogare:* withering of plants in the cold. *Yamazato:* mountain hamlets. *Kori-ike:* frozen ponds. *Mizudori:* waterfowl. *Yuki:* snow and its wintry symbolism. *Butsumyo:* prayers to the Buddha on December 19 to remove sins committed over the past year. *Tsuina:* the exorcism rite carried out on December 31; palace guards, screaming and shooting arrows into the air, customarily "drove the devils out." *O-tsugomori:* the last day of the year.

While the twelve most representative items from the above list might be selected for the months of the year, the rest were combined in many very different ways. The paintings were executed with one season per panel, the set of four forming a pair

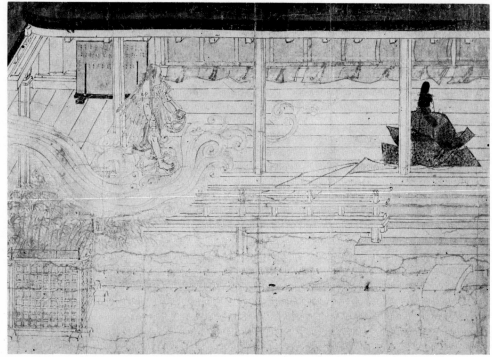

39. Section from the Engi Kaji *(Engi Incantation) scroll of the* Shigi-san Engi Emaki *(Legends of Shigi-san Temple Picture Scroll). Colors on paper; height, 31.5 cm. Second half of twelfth century. Chogosonshi-ji, Nara.*

of screens; or, in some instances, all four seasons might be painted on a single panel.

By now the reader has begun to realize the unusual scope of the term "seasonal things" as applied to the foregoing list of four-seasons subject matter. The things of nature, such as plants or animals, are indeed present, but we also have various natural phenomena, such as the weather or climatic conditions. Even events of human society come into play, which is to say that the "seasonal things" of the *yamato-e* transcend the material dimension. Though an *ayame* may have been chosen as a subject, the painting that resulted was infinitely more than a depiction of a plant; and a work that showed the moon was much more than a painting of a heavenly body. An *ayame* evoked the social event connected with it. Artists saw this plant in terms of the annual Boys' Festival held on the

fifth of May: the *Tango no Sekku.* For this reason, the so-called *ayame* theme was also known as the fifth-of-May theme. The moon theme (*tsukimi*), on the other hand, might mean moon viewing, but then again, it could mean a moon theme of the night of August 15. Thus, the "things" of *shiki-e* were hardly confined to, though they included, nature and natural phenomena; the natural was always so interwoven with human life that, in point of fact, the painting ended up as the depiction of recurring seasonal events, some religious, some not. The starting point for these events was the special connection between the unfolding of the seasons and the unfolding of human life. The union of the two can be construed as of neither man's nor nature's making; rather, the inseparableness is simply there—and that is exactly the situation that *shiki-e* in the Yamato style strove to set down as it was. If

40. Detail from the Suzumushi *(Bell Cricket) scroll of the* Genji Monogatari Emaki *(The Tale of Genji Picture Scroll).*
Colors on paper; dimensions of entire painting: height, 21.8 cm.; width, 48.2 cm. Early twelfth century. Goto Art Museum, Tokyo.

41. Section from the Kashiwagi *scroll of the* Genji Monogatari Emaki *(The Tale of Genji Picture Scroll).* Colors on paper; *dimensions of entire painting: height, 21.8 cm.; width, 48.2 cm. Early twelfth century. Tokugawa Art Museum, Nagoya.*

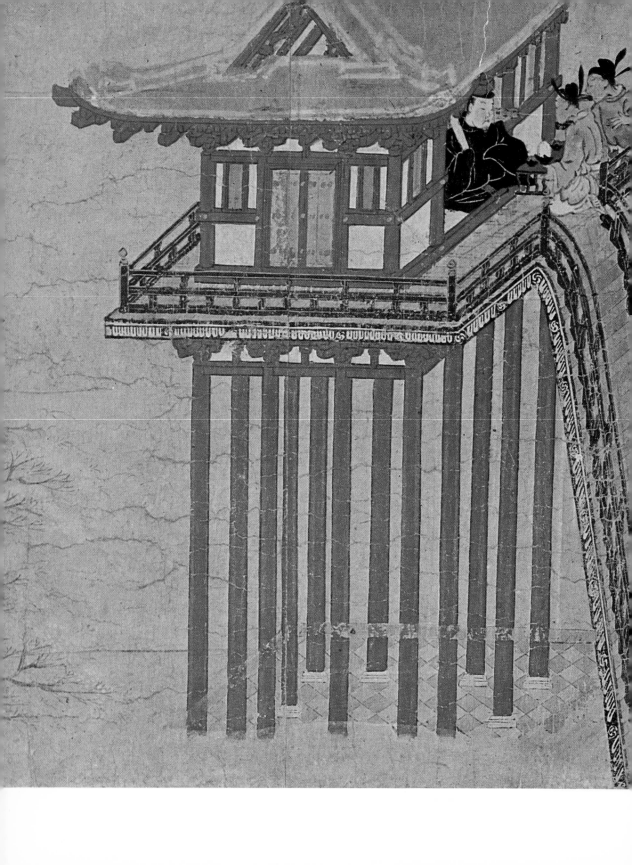

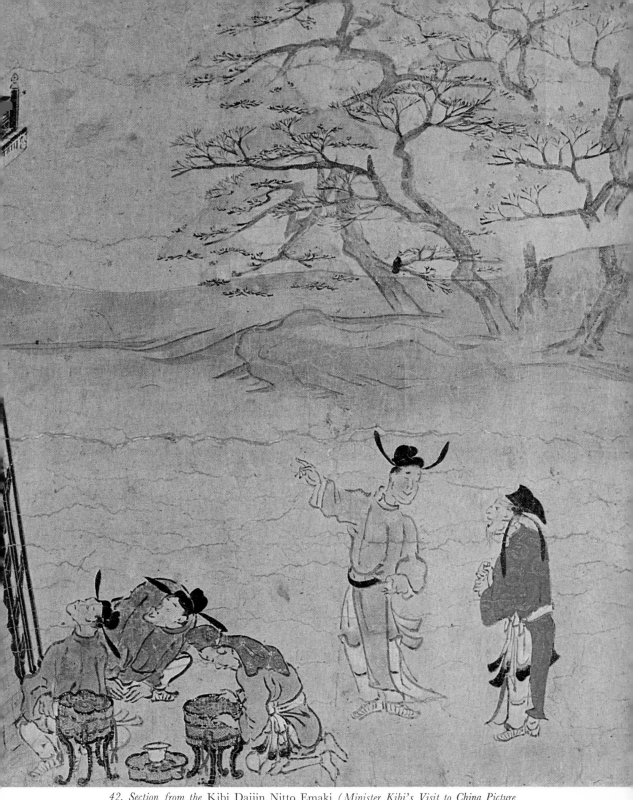

42. Section from the Kibi Daijin Nitto Emaki *(Minister Kibi's Visit to China Picture Scroll). Colors on paper; height, 32.1 cm. Late twelfth century. Boston Museum of Fine Arts.*

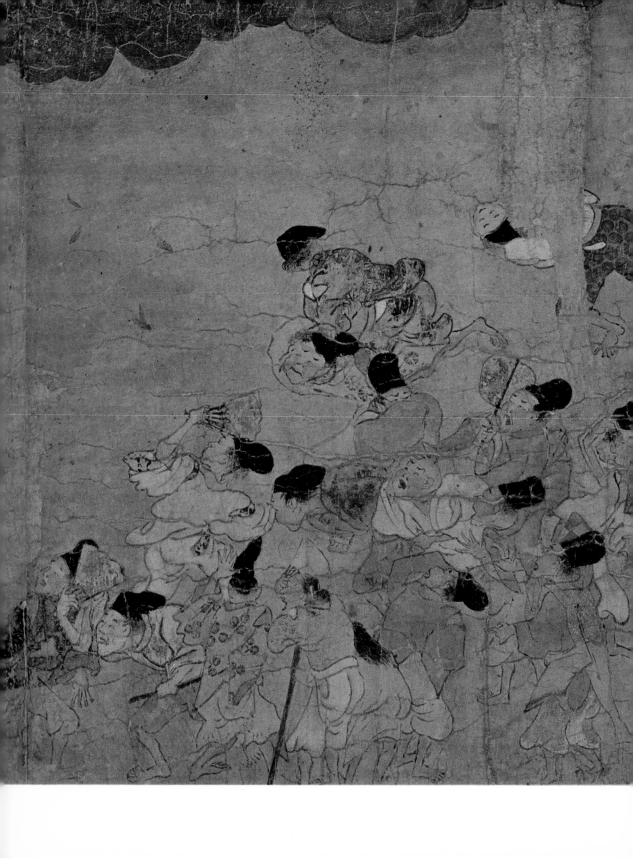

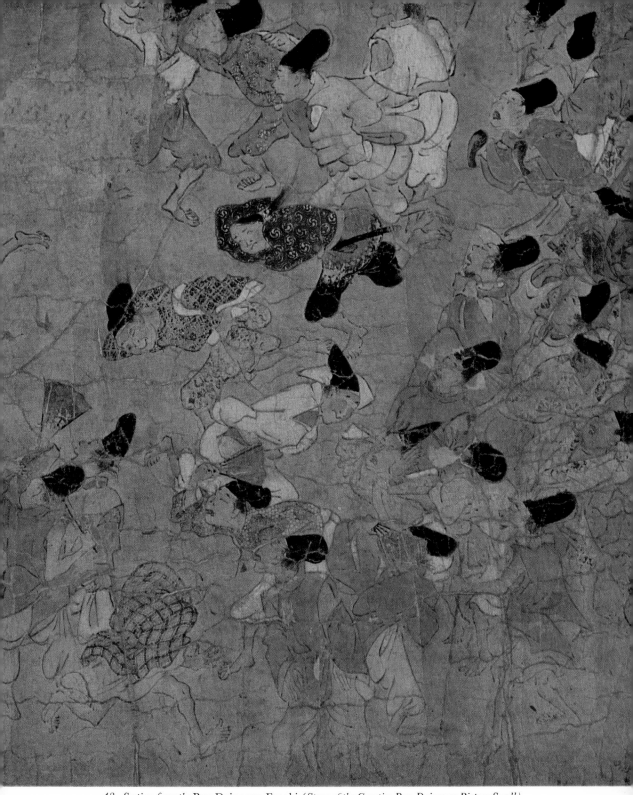

43. Section from the Ban Dainagon Emaki *(Story of the Courtier Ban Dainagon Picture Scroll).*
Colors on paper; height, 31.5 cm. Second half of twelfth century. Sakai Collection, Tokyo.

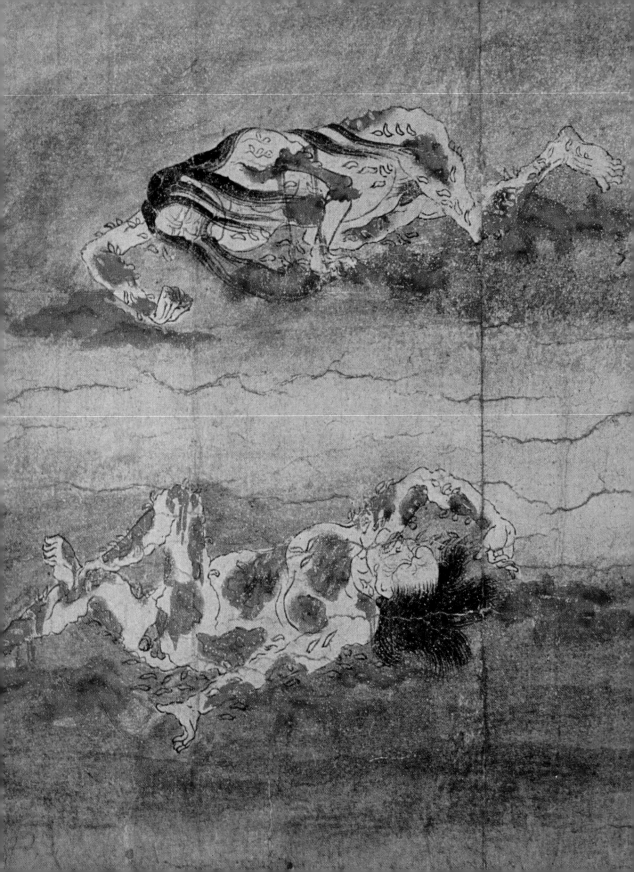

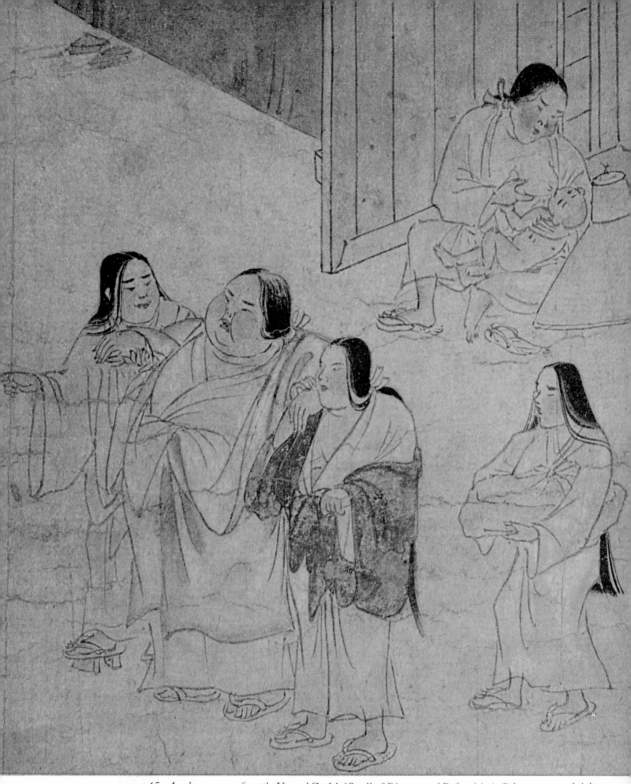

45. An obese woman from the Yamai Zoshi *(Scroll of Diseases and Deformities)*. Colors on paper; height, 25.4 cm. Late twelfth century. Matsunaga Memorial Museum, Odawara, Kanagawa Prefecture.

◁ 44. Section from the Jigoku Zoshi *(Scroll of Hell)*, Anju-in version. Colors on paper; height, 26.1 cm. Late twelfth century. Tokyo National Museum.

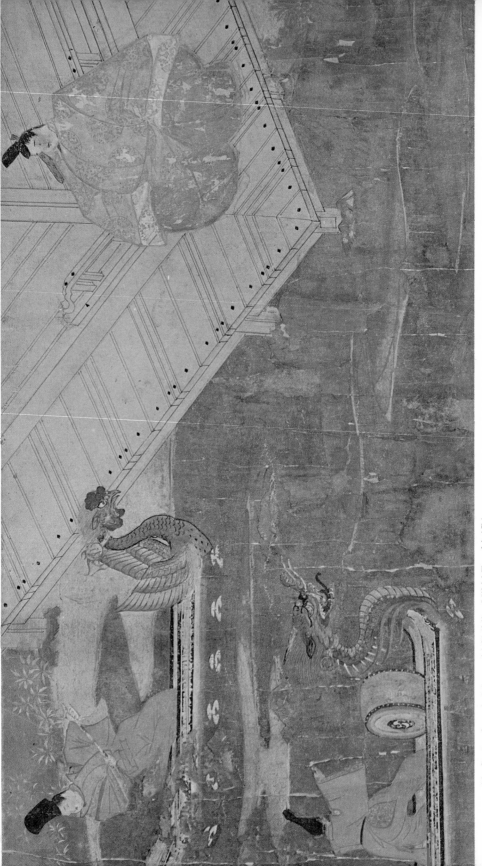

46. Section from the Murasaki Shikibu Nikki Emaki (Diary of Lady Murasaki Picture Scroll). Colors on paper; height, 23.9 cm. About mid-thirteenth century. Fujita Art Museum, Osaka.

▽ 47. Section from the Nezame Monogatari Emaki (Tale of Nezame Picture Scroll). Colors on paper; height, 25.8 cm. Early thirteenth century. Yamato Bunkakan, Nara.

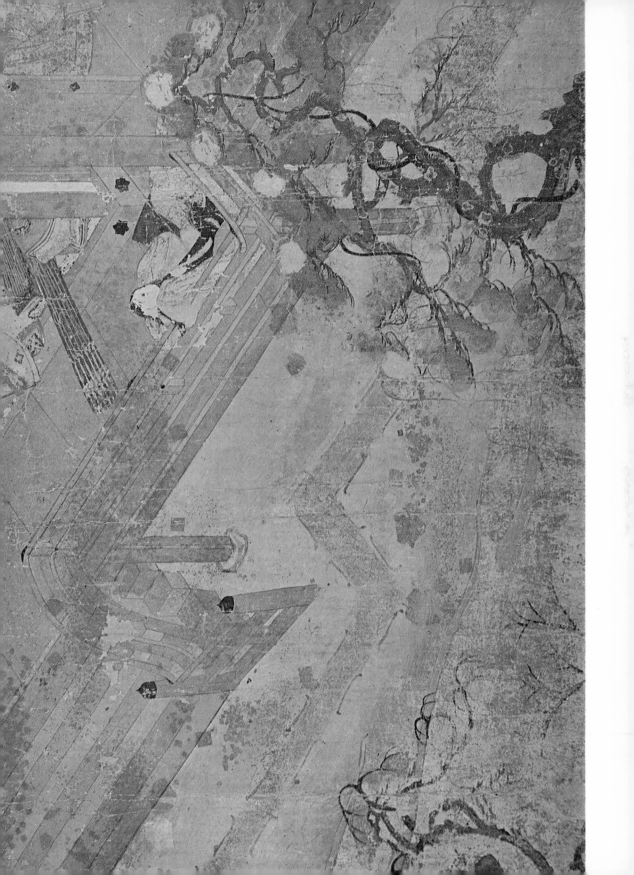

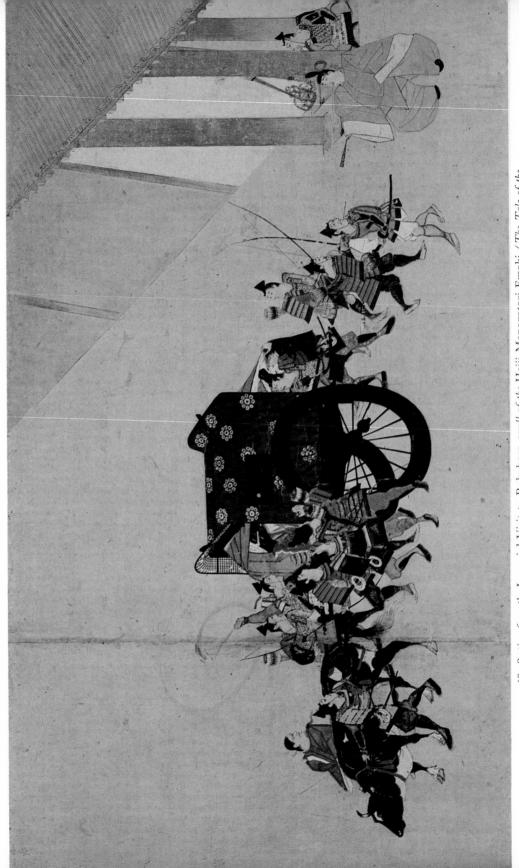

48. *Section from the Imperial Visit to Rokuhara scroll of the Heiji Monogatari Emaki (The Tale of the Heiji Rebellion Picture Scroll). Colors on paper; height, 42.4 cm. Late thirteenth century. Tokyo National Museum.*

49. Section from the Ise Monogatari Emaki (Tales of Ise Picture Scroll). Colors on paper; height, 26.8 cm. Early fourteenth century. Kubo Collection, Osaka.

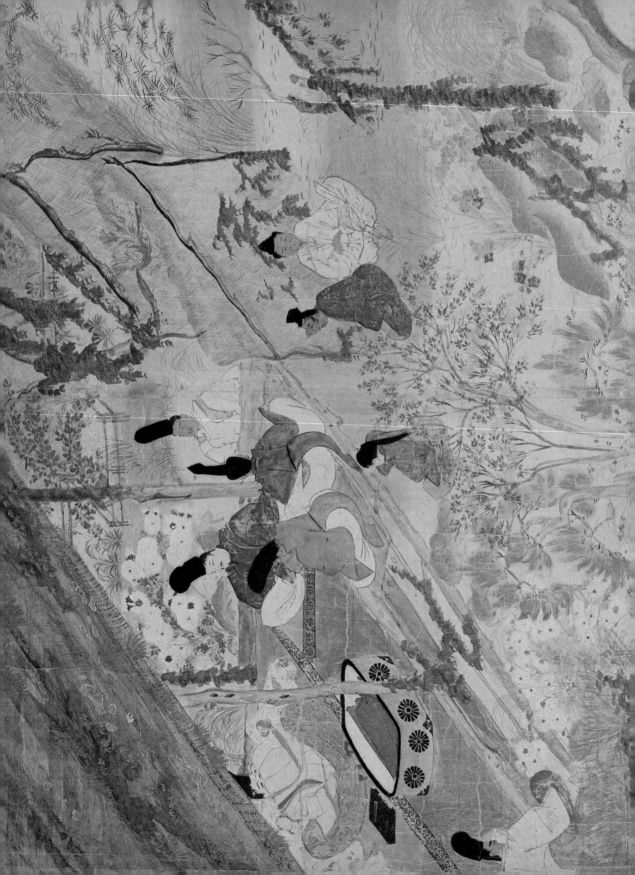

△ 50. Section from the Kitano Tenjin Engi (Legends of Kitano Tenjin Shrine) picture scroll. Colors on paper; height, 51.5 cm. Second half of thirteenth century. Kitano Temman-gu, Kyoto.

51. Section from the Ishiyama-dera Engi (Legends of Ishiyama-dera) picture scroll, attributed to Takashina Takakane. Colors on paper; height, 33.6 cm. Early fourteenth century. Ishiyama-dera, Shiga Prefecture.

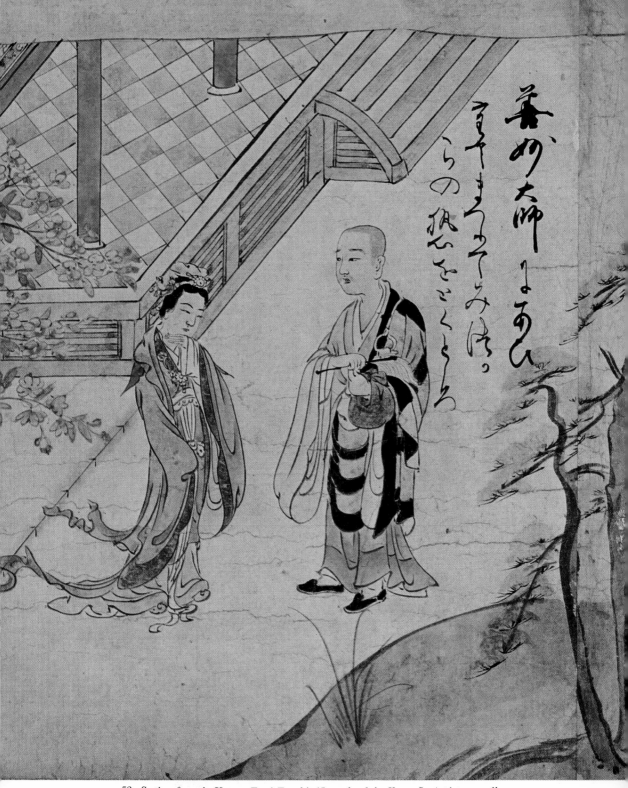

善妙大師はすらひ
すすまうてりの法の
らの恐をさくらる

52. *Section from the* Kegon Engi Emaki *(Legends of the Kegon Sect) picture scroll. Colors on paper; height 31.5 cm. First half of thirteenth century. Kozan-ji, Kyoto.*

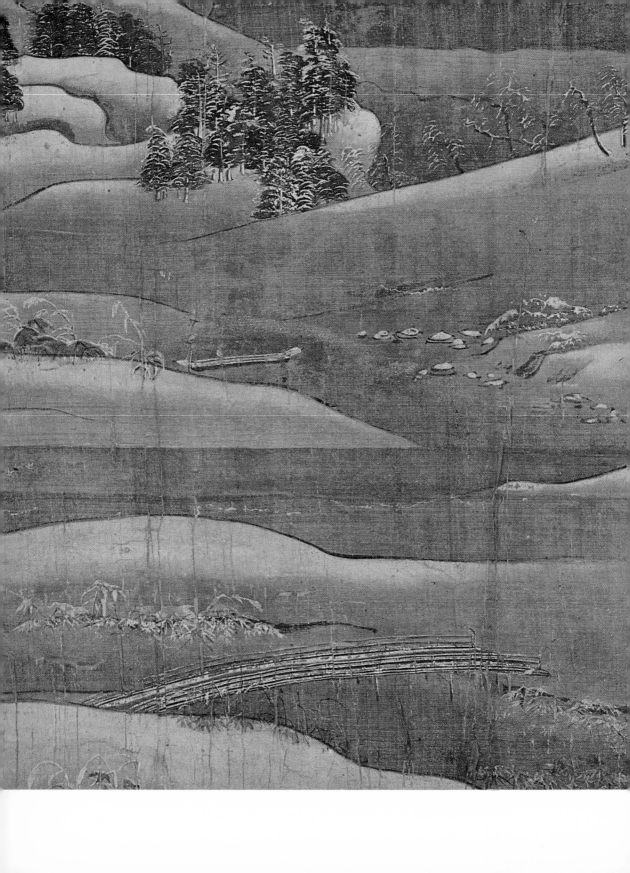

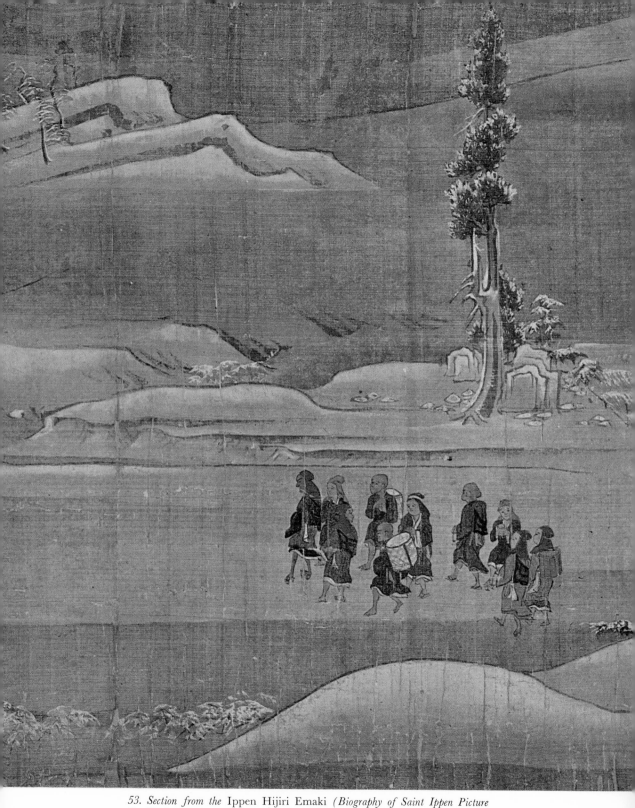

53. Section from the Ippen Hijiri Emaki *(Biography of Saint Ippen Picture Scroll)*, by En'i. Colors on silk; height, 38.2 cm. Dated 1299. Kankiko-ji, Kyoto.

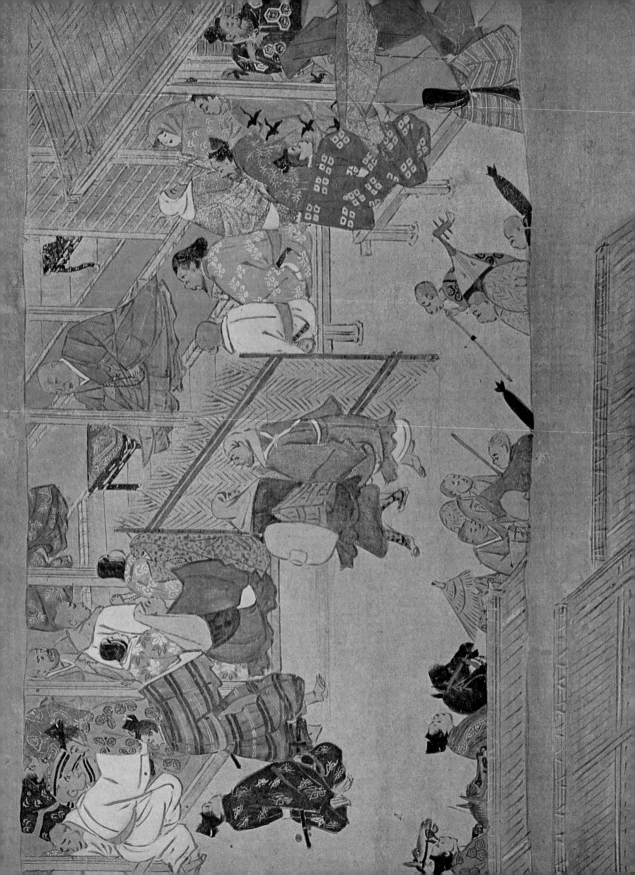

△ 54 (above). Section from the Honen Shonin Gyojo (Biography of Saint Honen) picture scroll. Colors on paper; height, 32.8 cm. Early fourteenth century. Chion-in, Kyoto.

55 (below). Section from the Boki Emaki (Life of Priest Kakunyo Picture Scroll). The tokonoma in the room on the right shows a hanging scroll of Kakinomoto no Hitomaro, the "god of poetry." Such paintings were the objects of veneration from the late Heian period. Colors on paper; height, 32.1 cm. Dated 1351. Nishi Hongan-ji, Kyoto.

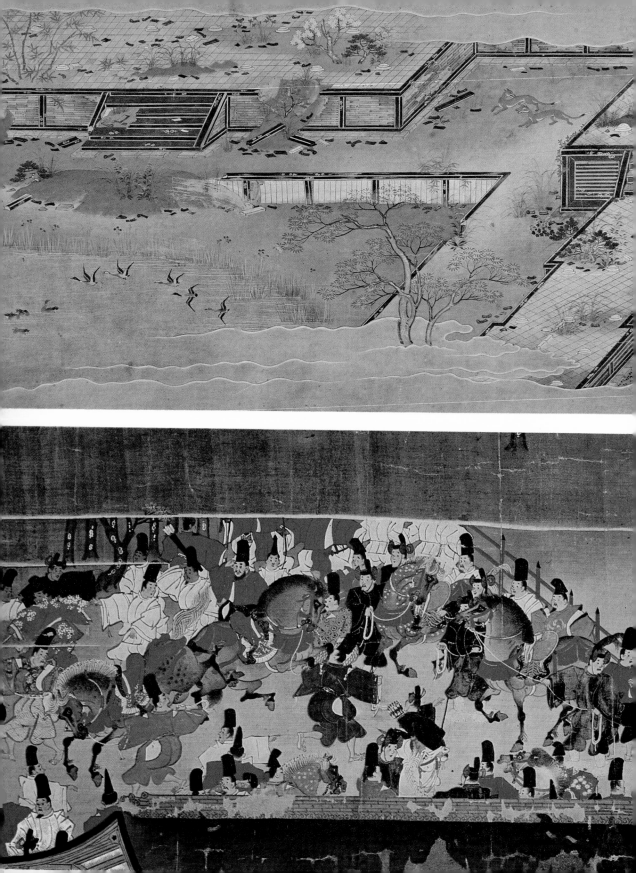

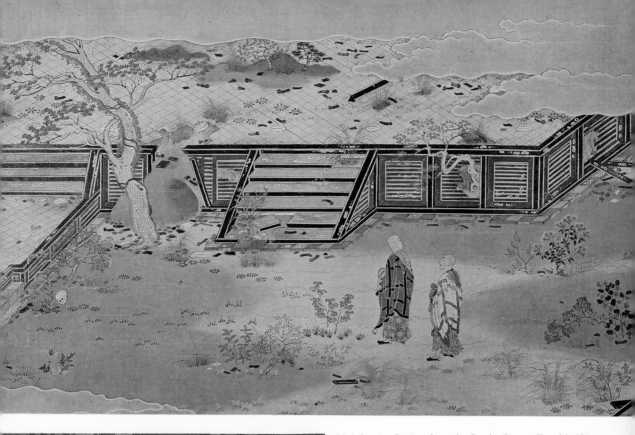

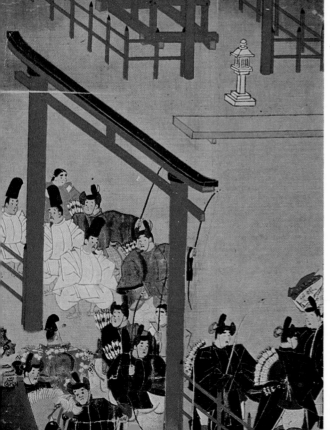

56 (above). Section from the Genjo Sanzo Emaki (Picture Scroll of the Travels of Genjo Sanzo to India), attributed to Takashina Takakane. Colors on paper; height, 40.3 cm. Early fourteenth century. Fujita Art Museum, Osaka.

57. Section from the Kasuga Gongen Kenki (The Kasuga Gongen Miracles) picture scroll, by Takashina Takakane. Colors on silk; height, 41.2 cm. Dated 1309. Imperial Household Collection.

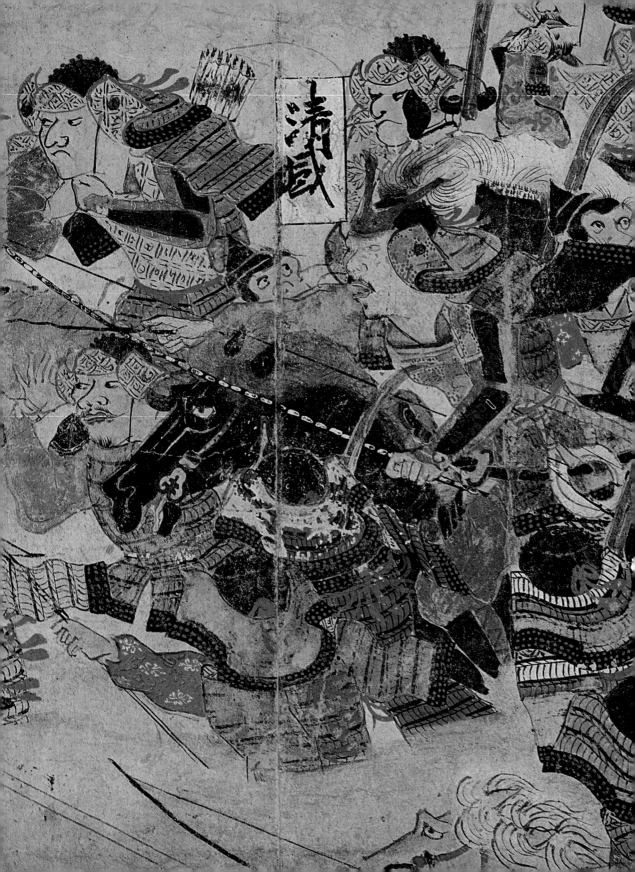

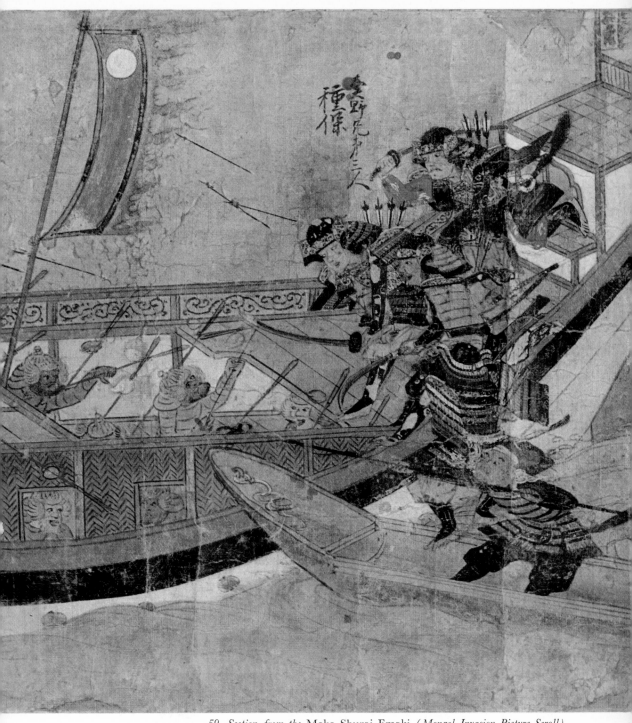

熊野兄カニ人
種保

59. Section from the Moko Shurai Emaki (Mongol Invasion Picture Scroll).
Colors on paper; height, 39.4 cm. Dated 1293. Imperial Household Collection.

◁ 58. Detail from the Battle of Rokuhara scroll of the Heiji Monogatari Emaki (The Tale of the Heiji Rebellion
Picture Scroll). Colors on paper; height, 17.3 cm. Early fourteenth century. Maeda Collection, Kanagawa Prefecture.

61. Section from the Ise Shin Meisho Uta-awase Emaki *(Picture Scroll of the Poetry Contest on Newly Selected Scenic Spots in Ise). Colors on paper; height, 32.1 cm. Dated 1295. Ise Grand Shrine Repository, Mie Prefecture.*

◁ 60. Section from the Saigyo Monogatari Emaki *(Picture Scroll of the Biography of Priest Saigyo).*
Colors on paper; height, 31.8 cm. About mid-thirteenth century. Tokugawa Art Museum, Nagoya.

62. Section from the Yuzu Nembutsu Engi Emaki (*Legends of the Yuzu Sect Picture Scroll*),
by Tosa Yukihiro and his students. *Colors on paper; height, 41.5 cm. Dated 1414. Seiryo-ji, Kyoto.*

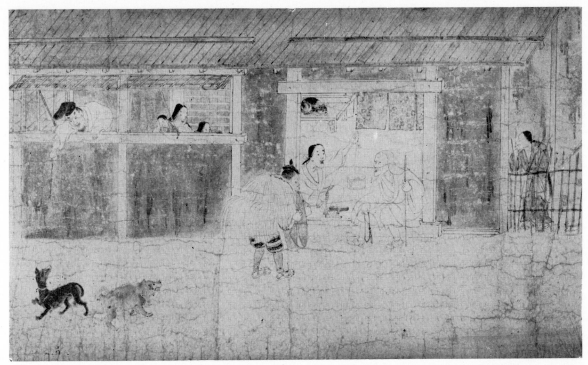

63. *Section from the* Amagimi *(Noble Nun) scroll of the* Shigi-san Engi Emaki *(Legends of Shigi-san Temple Picture Scroll).* *Colors on paper; height, 31.5 cm. Second half of twelfth century. Chogosonshi-ji, Nara.*

one looks only at the plums, the chrysanthemums, or wild geese in *shiki-e,* the mind immediately jumps to a host of parallels in Chinese ink painting. At first glance, *yamato-e* has all the marks of the *kachoga* (bird-and-flower painting). But a true understanding of what went into the actual painting of a four-seasons theme sets in relief the absolute differences between the two.

Kachoga may be described as the depiction of birds and flowers lifted out of their natural setting, the object being to suggest the whole of nature by throwing into relief just one part of it. The birds and flowers in *shiki-e,* on the other hand, found themselves under no such metaphysical obligation; they only had to be birds and flowers people find around them. They were depicted in what might be called a concrete manner—not isolated from their environment, no process of abstraction ap-

plied, shown just as they were found in their relationship to man. One looks in vain for single-flower depiction in *shiki-e.* The reason is that real flowers always bloom on a hill, in a field, or in a garden; so that is how these were painted. But nevertheless, *shiki-e* flowers were not given the purely objective treatment of strict naturalism either. Nature unconnected with human life cannot exist without the conceptualization of science—that is, abstraction. The nature that we experience so concretely is inevitably nature as man's environment. This is why *shiki-e* in the Yamato style dealt with nature as it is, necessarily treating it as the setting for human life. Take a Yamato painting with a plum theme, for example. Someone is always there looking at the plums; or the depiction of a cuckoo will always have someone listening. There are some paintings, however, that do not even show a

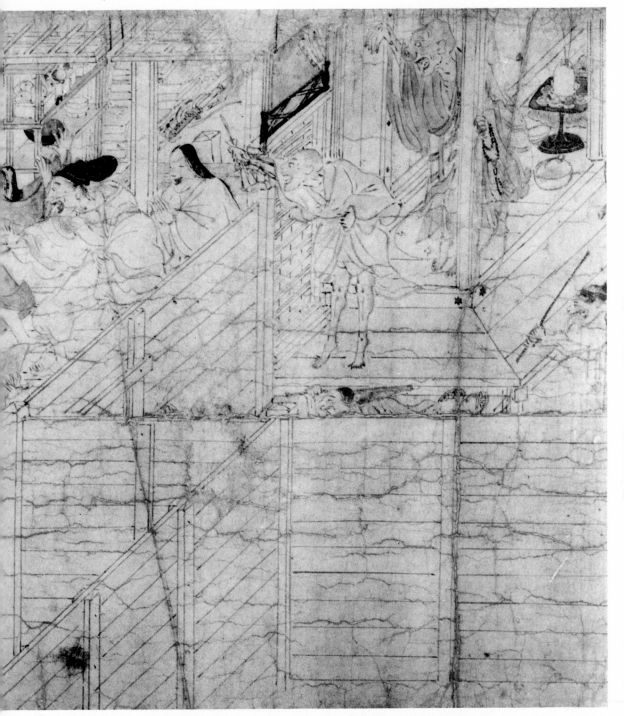

64. *The bowl flying out of the storehouse. From the* Shigi-san Engi Emaki *(Legends of Shigi-san Temple Picture Scroll). Colors on paper; height, 31.5 cm. Second half of twelfth century. Chogosonshi-ji, Nara.*

cuckoo, but only a person or persons attentively listening to the cuckoo's song.

LOST PAINTINGS As I said before, all the screen and panel paintings of Heian times seem lost to history, and this unfortunate lack of examples makes close scrutiny of *shiki-e* impossible. The few paintings to be found among the scrolls of the Kamakura period (Fig. 28); the scroll painted in the first half of the seventeenth century by Sotatsu, who derived the motifs in it from Kamakura-period scrollwork (Fig. 24); and some seeming vestiges of Heian-period screenwork, namely, the landscape screen panel of Jingo-ji temple (Fig. 27), are helpful, but still leave much to guesswork. Nevertheless, we know there existed panels and screens, to the top half of which were pasted *shikishi* (square sheets of paper) with poems echoing the subject matter of the picture. The survival rate of *waka* poetry is excellent, and even though the paintings themselves perished, the accompanying verses, happily enough, have come down in great number, either in the collections of poems selected and published by imperial command, or in various private or anonymous anthologies. This makes it possible to visualize the contents of the original paintings to some degree. Our sources on screen and panel painting in the Yamato style from the Heian period are so limited that without these poems no substantial research would be feasible in the field at all. So here we might look at a sampling of verse from such collections.

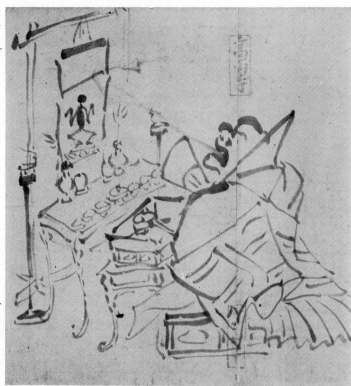

65. *Section from the* Animal Scroll *of the Cho-ju Jimbutsu Giga (Scroll of Frolicking Animals and People), attributed to Toba Sojo (Kakuyu). Ink on paper; height, 30.6 cm. First half of twelfth century. Kozan-ji, Kyoto.*

66. *Detail from the* Human-Figure Scroll *of the* Choju Jimbutsu Giga *(Scroll of Frolicking Animals and People). Ink on paper; height, 30.9 cm. First half of thirteenth century. Kozan-ji, Kyoto.*

These lines [a literal translation] were actually used with paintings, and perhaps they will give us some idea of *shiki-e.*

"A house with the women going out in the garden to look at plum blossoms • A traveler on his way, the wild geese going back • Droves of people come to frolic in the fields in spring • Womenfolk flocking to see the fields in autumn • Come courting at her home, he stands at the bamboo fence by the flowering *susuki* • The end of September, her carriage passing in a flurry of falling maple leaves • The traveler on his journey, gazing on snowy pines • Morning in a house of night-long purification prayers. The chief priest leaves, the monks rest in the garden as snow begins to fall."

Plum blossoms, geese going back, enjoying fields in spring and autumn, *susuki* (Japanese pampas grass), maple leaves, snow, Buddhist purification —these were the themes of *shiki-e,* and even these few explain what this kind of painting was all about. There is no mistaking it for natural depiction. In fact, it would seem fitting to call it genre painting (*fuzokuga:* the painting of manners or customs that grew out of the *sezokuga,* or secular painting); for it leans less to the landscape category, and more to genre depiction. But then again, its aims are not only those of genre either. It is not simply natural representation; it is not simply genre. The conclusion is that we have in *shiki-e* in the Yamato style that rare phenomenon in the art world—the beautiful blend of the two.

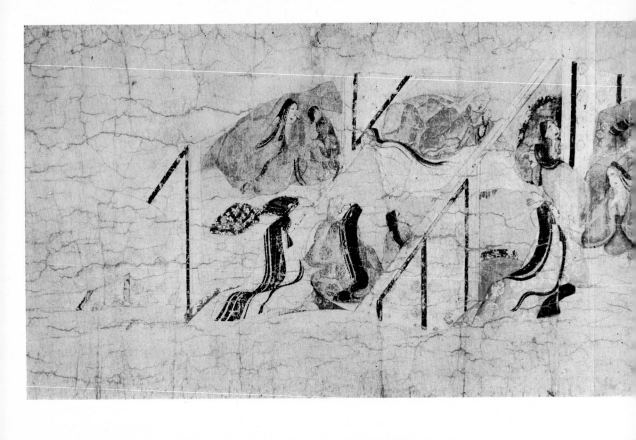

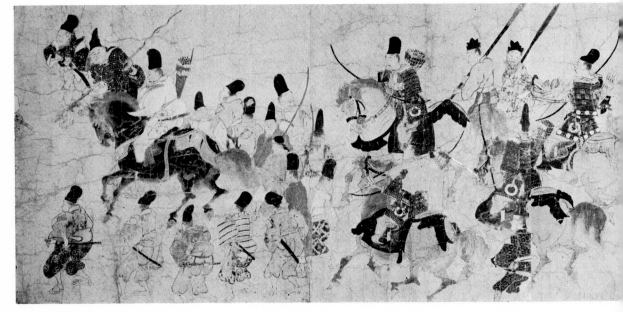

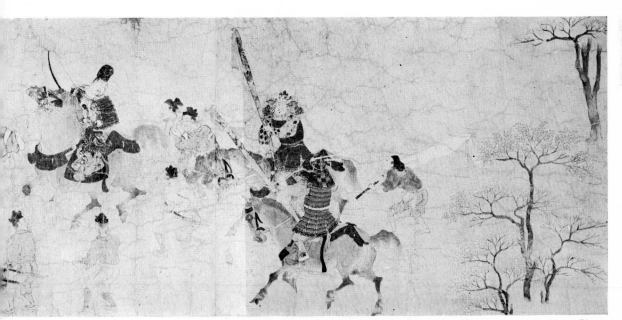

67, 68. Two sections from the Ban Dainagon Emaki *(Story of the Courtier Ban Dainagon Picture Scroll). Colors on paper; height, 31.5 cm. Second half of twelfth century. Sakai Collection, Tokyo.*

69. *Section from the* Yoshinobu-shu *division of the* Sanju-roku-nin Shu *(Thirty-six Poets' Anthology). Ink on decorated paper; height, 20.1 cm.; width, 16 cm. First half of twelfth century. Nishi Hongan-ji, Kyoto.*

70 *(opposite page, top). Section from the* Akahito-shu *division of the* Sanjuroku-nin Shu *(Thirty-six Poets' Anthology). Ink on decorated paper; height, 20.5 cm.; width, 32 cm. First half of twelfth century. Nishi Hongan-ji, Kyoto.* ▷

71 *(opposite page, bottom). Section from the* Shigeyuki-shu *division of the* Sanjuroku-nin Shu *(Thirty-six Poets' Anthology). Ink and colors over paper collage; height, 20.1 cm.; width, 31.8 cm. First half of twelfth century. Nishi Hongan-ji, Kyoto.* ▷

FAMOUS-PLACE PAINTINGS Along with *shiki-e*, the depiction of famous places (*meisho-e*) was common in the screen and panel paintings. Though the latter drew upon famous places in Japan for subject matter, the artist was not choosing from among sites of surpassing beauty he actually saw about him; instead, he took the much-romanticized places of *waka* poetry, the mere mention of which fired the imagination. These poetic locations were legion and included such places as Akashinoura, Ajironohama, Asukagawa, Amanohashidate, Ujinoajiro, Ogura-yama, Oharano, Kasugano, Karasaki, Sagano, Sarashina, Shiogamanoura, Sumanoura, Sumi-yoshi, Tagonoura, Tatsutagawa, Tsukubanoyama, Tennoji, Nagaranohashi, Naniwa, Hirosawanoike, Fujisan (or sometimes referred to as Fujinoyama),

Futamigaura, Miyagino, Musashino, and Yoshino-yama.

Meisho-e is the same as seasonal painting with respect to grouping a number of these sites together on a given set of screens or panels.

When one first encounters so many famous places appearing in paintings, the temptation is to congratulate the artist for his extensive journeys around the country so as to get a close-up of the locales. But most of the paintings were the fruit of poetic imagination, brushwork launched with a lyric name as inspiration. In certain specific instances the artist, of course, was quite familiar with a place, and the results are rather realistic. This may certainly be said of paintings involving spots close to Kyoto, such as Hirosawanoike, Osakano-seki, or Ujinoajiro. When the site was considerably

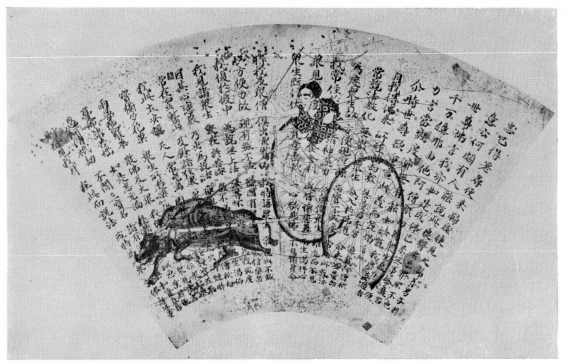

72. *Underpainting for a sutra on fan-shaped paper. Colors on paper; height, 27.4 cm. Second half of twelfth century.* *Shitenno-ji, Osaka.*

more remote, however, we may safely assume the artist was painting without having seen his subject matter. Intimations of a certain indolence among Kyoto artists may be surmised from a famous ballad by the composer-poet Noin Hoshi (988–?). Without budging from his Kyoto backyard he could rhapsodize of "leaving Miyako [Kyoto] with the mists of spring, and arriving in Shirakawano-seki in fall." (The journey from Kyoto to the then northernmost limits of Heian rule, now in Fuku-shima Prefecture, is some seven hundred kilometers by present-day rail. On foot this would easily have taken weeks.) There is little doubt that many art-ists who produced *meisho-e* suffered from similar laziness. It was much easier to paint places closer to the capital, like Kaigane or Tsukubanoyama, locales that asked little of, but still allowed plenty

of room for, artistic imagination. For this reason, *meisho-e*, though comparable to the landscape form, is quite different from what we call landscape painting today.

What, then, was the real aim of *meisho-e?* Was it really the painting of famous places as such? Of Suematsunoyama or Takasago? Not so, to judge by the "seasonal things" it incorporated in the same way as did *shiki-e*. It featured Kasugano surely, but as a place for the New Year's rite of gathering young wild shoots, not as landscape. Or Tatsutagawa, the famous river so often referred to, is really painted for reasons of maple viewing. The work itself is actually *shiki-e* in type, but *meisho-e* resorts to a kind of aesthetic name dropping.

Since the distinction between *meisho-e* and *shiki-e* seems to make no final, qualitative difference, there

73. *Cover of the* Gonno-bon *chapter of the* Heike Nokyo *(Heike Dedicatory Sutra) scrolls. Colors on paper; dimensions of cover: height, 29.4 cm.; width, 29.4 cm. Dated 1164. Itsukushima Shrine, Hiroshima Prefecture.*

is not much sense in enlarging upon it. I think the important thing is to recall that the same Yamato painting in both, whether on panels or screens, combines landscape and genre elements to form an indivisible unity.

We can only lament the near-total loss of all *shiki-e* on panels and screens which, as I mentioned earlier, sources say were prodigious during the Heian period. On the other hand, later painting, as noted also, gives us a fair idea of it; and several other extant works contemporary to Yamato painting, although in a different medium, show likenesses which allow us to reconstruct the case with panels and screens. The group of door paintings at the Phoenix Hall of the Byodo-in at Uji, dating from around 1053, provide a striking example. They belong to the *Amida raigo* genre and show the

advent of the Buddha Amida (Amitabha) surrounded by a host of Bodhisattvas. Although the form is Buddhist, the landscapes (Fig. 25), houses, and people in them are straight out of Yamato painting, as we can find them elsewhere. What is more, they belong to the *shiki-e* type. In 1955, when structural components of the Phoenix Hall were removed for renovation purposes, a seasonal indication for each Amida painting was found inscribed clearly in the doorframe of each. Thus, the painting of the Buddha on the north doors is for March, showing him with the *chubon josho* mudra; the Buddha with the *jobon chusho* mudra, painted on the right-hand doors of the east side, is for April; the south doors, with the Buddha shown with the *gebon josho* mudra, are for August; and the west doors depict *Nissokan* (the "Sunset Contemplation"

74. *Part of a four-seasons painting on a cypress fan. Colors on wood; width, 16 cm. Second half of twelfth century. Itsukushima Shrine, Hiroshima Prefecture.*

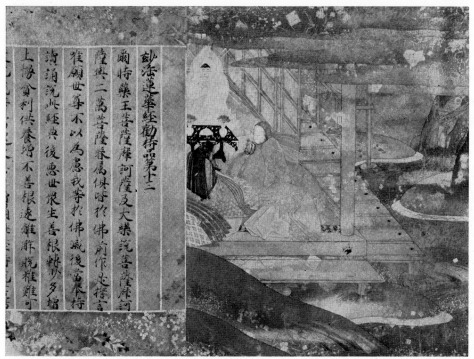

75. Frontispiece to the Kanji-bon *chapter of the* Heike Nokyo *(Heike Dedicatory Sutra) scrolls. Colors on paper; height, 29 cm.; width, 26.4 cm. Dated 1164. Itsukushima Shrine, Hiroshima Prefecture.*

Amida, an extremely old depiction and one rare in Japan).

Also from Heian times, there is a miniature painting on a cypress fan (Fig. 74) in the Itsuku-shima Shrine of Hiroshima which is similarly of the *shiki-e* type. All of these, added to what we see in the *Genji Monogatari* (Figs. 8, 29, 30, 36, 37, 40, 41, 95), other Heian picture scrolls, sutra illustra-tions (Figs. 13, 72, 73, 75, 83, 84, 98, 99, 134, 135, 150), and underpainting in poetry collections (Figs. 69–71, 96, 97, 133), yield painting compa-rable to *meisho-e* and *shiki-e* composition in *yamato-e*. Looking at them together with the written sources on hand, we can make out, however darkly, our lost legacy—the Heian-period *shiki-e* screens and panels, painted in the inimitable Yamato style.

CHAPTER FOUR

Picture Scrolls

I REMARKED EARLIER in passing that the picture-scroll (*emakimono*) form was the other important vehicle for Yamato painting, and it is mainly scrolls that survive. But strictly speaking, it is not *emakimono,* but rather *kami-e* (literally, "paper pictures") that should be distinguished from the type of *yamato-e* paintings to be found on panels and screens. The term *kami-e* is more suitable because it includes both picture scrolls and the bound picture books known as *soshi-e* (literally, "book pictures"). *Kami-e* is no longer used now, but it meant small-sized paintings one could enjoy, say, set on a table, as opposed to the large-scale paintings on screens or panels used for interior furnishings during the Heian period. Unlike the later ukiyo-e prints that were made to be enjoyed by themselves, *kami-e* were painted as books of story illustrations that correspond to the *ehon* picture books of later times.

LINK WITH
LITERATURE

From the very first, Yamato-style painting was connected with literature, and it defies understanding as a genre apart from it. I said before that screen and panel paintings were directly linked to literature by means of *shikishi* paper pasted to the paintings and carrying a verse inscription, usually a *waka* poem. But not all screens and panels depict the four seasons. Here and there *monogatari* (romantic tales of the tenth and eleventh centuries) painting appeared. Actually, *shiki-e* had the temporal element so essential to the *monogatari* movement. We find the progressive unfolding of the seasons and life, and there are love-story themes carried through on a series of *shiki-e* panels or screens. The leap to *monogatari*-type illustration would not at all have been surprising. Corroborating this is the set of five twofold screens (originally in panels) of the *Shotoku Taishi Eden* (Pictorial Biography of Shotoku Taishi; Fig. 23) by Hata no Munesada, dating from 1069 and formerly in the Picture Hall of Horyu-ji temple, Nara. But perhaps because the form for reading was more convenient, *monogatari* painting on panels and screens was the exception rather than the rule. It was much easier to enjoy one of the famous tales as reading material in convenient scroll or book form, and so these became the usual vehicle. But even with large formats, such as screens or panels, Yamato-style painting tended not to employ the broad, unified composition later used in ink-painting and the Kano school's works on screens and partitions. Instead, there was a preference for a composition conceived as a series of small paintings, and the resulting form was eminently suited to a literary kind of appreciation. When we come to the smaller format of *kami-e,* this literary character is even stronger, and the connection with literature becomes that much closer than in the case of screens and panels.

As with screen or panel painting, *kami-e* was a child of the Heian nobility and its peculiar life style. The upper class had become soft and seden-

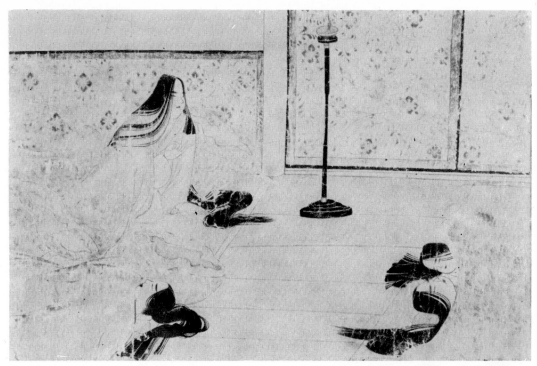

76. Fuminsho no Onna *(Lady Insomniac)*. *Scene from the* Yamai Zoshi *(Scroll of Diseases and Deformities)*, *Sekido version. Colors on paper; height, 26.1 cm. Late twelfth century. Sekido Collection, Aichi Prefecture.*

tary, it would seem, the womenfolk especially growing more and more fond of indoor recreations. Ladies' ennui and search for entertainment lay behind the immense popularity of "tale" literature, which reached a peak in the masterful *Genji Monogatari* (The Tale of Genji), the great novel of Japanese court life written by Murasaki Shikibu early in the eleventh century and later made the subject of a number of picture scrolls. Instead of merely reading a book of tale narrative, people found it doubly delightful when the verse was read to them, while illustrations of the story were being enjoyed separately (Fig. 37). The age soon saw the marriage of *monogatari* and painting which, in turn, created the vogue in *kami-e*. In short, *kami-e* began as illustration for "tale" literature. It was a delicate path to tread: the painting could not draw too much attention to itself or the verse would become second-

ary. On the other hand, the painting was not just accessory illustration either; the special possibilities of the medium were explored to the fullest, and it was here again that Yamato painting staked out a special aesthetic claim.

Though Yamato painting distinguished itself in the field of literary illustration, the picture-book medium was by no means a Japanese invention. Panel and screen painting in Japan had originated in China, and this was generally true of picture books also. In scanning the Chinese literary art materials that came into Japan around the end of the ninth century, we find many books with names that suggest they contained paintings: *Lieh Nü Ch'uan T'u* (Pictorial Biography of a Chaste Lady), *Hsiao Tzu Ch'uan T'u* (Pictorial Biography of a Devoted Son), *Chung Hsiao T'u* (Pictures of Loyalty and Filial Devotion), *Ts'ai Yao T'u* (Pictures of

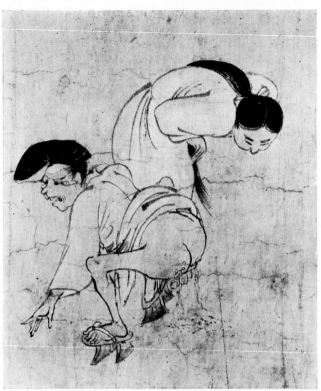

77. Jiro no Otoko *(Man with Anal Fistula). Detail from the* Yamai Zoshi *(Scroll of Diseases and Deformities), Sekido version. Colors on paper; height, 26.1 cm. Late twelfth century. Sekido Collection, Aichi Prefecture.*

78. *Detail from the* Tori Jigoku *(Hell of the Monstrous Chickens) section of the* Jigoku Zoshi *(Scroll of Hell), original. Colors on paper; height, 26.7 cm. Late twelfth century. Nara National Museum.* ▷

Herb Gathering), *Pen Ts'ao T'u* (Pictures of Plants), and *Shen Hsien Chih Ts'ao T'u* (Pictures of Divine Fragrant Grasses). These clearly underscore the early preference intellectuals had for picture books.

Examples also exist of Life-of-Buddha paintings decorating the space above sutras such as the *Kako Genzai Inga-kyo* (Sutra of Cause and Effect in the Past and Present; Fig. 15), dating from 764. (This sutra belongs to the group called *Tempyo E Inga-kyo,* or Tempyo Era Sutra of Cause and Effect.) Some would make sutra work the forerunner of our picture scrolls; but inclusion of illustrations in books certainly was not a phenomenon confined to Buddhist sutras, and in any case, it is hard to credit our Japanese ancestors with any special creativity for having come up with the picture-book idea in the first place. Books in general took two forms—the bound format we know today, and the

scroll format, the latter being the more common. Picture books, also, were of two forms—the bound picture book and the picture scroll, and of these two the picture scroll was the more popular form by far.

There is a wealth of extant picture scrolls from China: the *Nü Shih Chen T'u Chüan* (Illustrated Admonitions of the Court Steward; Fig. 20) by the famous artist and man of letters, Ku K'ai-chih of Eastern Chin (317–420); picture scrolls produced from the Six Dynasties (222–581) up through the T'ang period (618–907); and also a host of recognizable copies. Another tie between "tale" literature and painting was the custom of reading a narrative while showing the accompanying pictures. (The lector's script was called *hembun.*) Special picture scrolls were painted just for the purpose. One actual such example has been dis-

covered in Tunhuang in China: a picture scroll showing the Buddha subjugating demons, with the lector's script on the back.

Thus tale illustrations and picture scrolls were not exclusive to *yamato-e* as far as the form is concerned, but the content is original and displays typically Japanese characteristics. The genre produced numerous masterpieces highly valued as uniquely Japanese art. A good number of picture scrolls have been preserved, and even if we restrict ourselves to Heian works, unlike panel and screen paintings, there are several examples of masterpieces extant from this period. Let us now take a look at some of these in order to consider the special characteristics of Yamato picture scrolls.

HEIAN-PERIOD PICTURE SCROLLS

Picture scrolls definitely dating back to Heian times are not abundant, and what is extant can be traced to the days of the *insei,* or the system of the cloistered emperors, from the end of the eleventh to the end of the twelfth century, when emperors abdicated prematurely but really retained their ruling power. Little or nothing may be found from the tenth- and eleventh-century rule of the great Fujiwara clan. The verdict of recent research is to place the *Genji Monogatari* (The Tale of Genji) picture scroll (Figs. 8, 29, 30, 36, 37, 40, 41, 95) and the older sections of the *Choju Jimbutsu Giga* (Scroll of Frolicking Animals and People; also often referred to as *Choju Giga;* Figs. 34, 35, 65, 66) in and around the reign of Emperor Toba

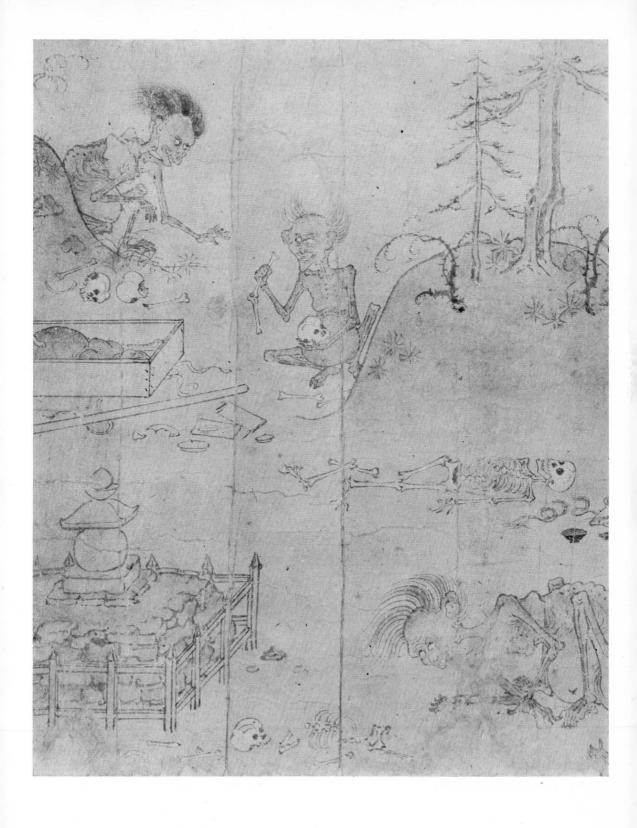

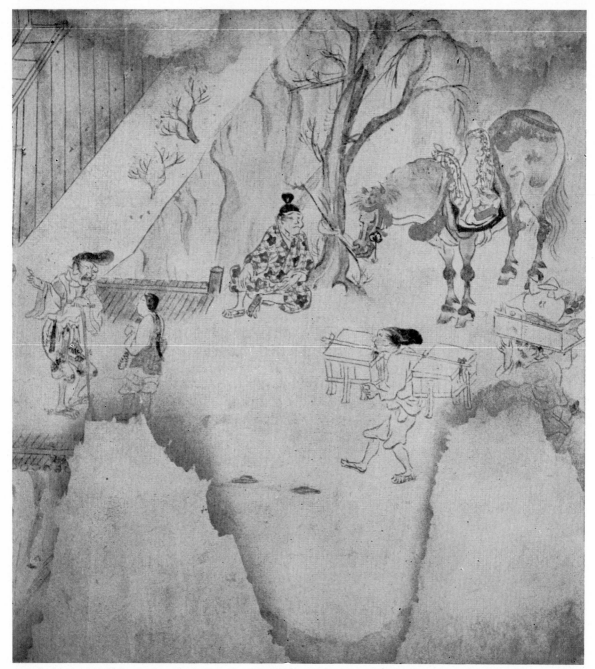

81. *Section from the* Kokawa-dera Engi *(Legends of Kokawa-dera) picture scroll. Colors on paper; height, 30.6 cm. Late twelfth century. Kokawa-dera, Wakayama Prefecture.*

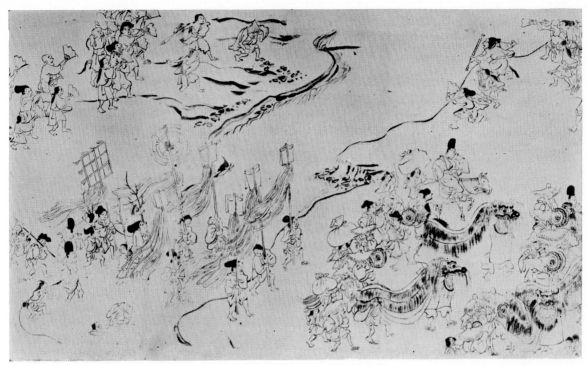

82. *Festival procession of the Inari Shrine. From the* Nenju Gyoji Emaki *(Picture Scroll of Annual Rites and Ceremonies). Ink on paper; height, 31.8 cm. A copy by Sumiyoshi Jokei (1599–1670), based on a twelfth-century original. Tanaka Collection, Tokyo.*

(1107–23). Then, dating approximately from the second half of the twelfth century, during the days of the Taira clan, we have the following scrolls: *Shigi-san Engi* (Legends of Shigi-san Temple; Figs. 11, 31, 32, 38, 39, 64), *Ban Dainagon* (Story of the Courtier Ban Dainagon; also called *Tomo no Dainagon;* Figs. 10, 33, 43, 67, 68, 116), *Gaki Zoshi* (Scroll of Hungry Ghosts; Figs. 9, 80), *Kokawa-dera Engi* (Legends of Kokawa-dera; Fig. 81), and *Kibi Daijin Nitto* (Minister Kibi's Visit to China; Fig. 42). In the form of copies there are the *Nenju Gyoki Emaki* (Picture Scroll of Annual Rites and Ceremonies; Figs. 82, 115) and the *Joan Go-sechi Emaki* (Picture Scroll of the November Festival at the Imperial Palace in the Joan Era; Fig. 132). Again, different from scrolls, but excellent *kami-e* work nonetheless, are the frontispieces to *Kuno-ji Kyo*

(Kuno-ji Sutra; Fig. 83), dating from around 1141, and the *Heike Nokyo* (Heike Dedicatory Sutra; Figs. 12, 75). Also from around the same time, the underpainting for the *Kanfugen Kyo* (Dharmamitra Sutra; Fig. 99) illustrates a *waka* in the *Kokin-shu* anthology. The scene of lords and ladies by the charcoal fire makes the life of the Heian-period nobility tangible. Furthermore, we also have various fan-shaped sutra underpaintings (Figs. 13, 72, 84), probably executed around the beginning of the Kamakura period. In combination with the picture scrolls, they allow us to see the aesthetic quality of painting in the Yamato style during Heian times. Although sutra painting, these *kami-e* have single scenes which are apparently based on the *Genji* or *Ise Monogatari,* so they belong, at least partially, to the *monogatari* illustration form.

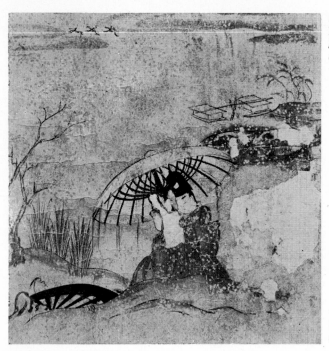

83. *Frontispiece to the* Yakusoyu-bon *chapter of the* Kuno-ji Kyo *(Kuno-ji Sutra). Colors on paper; height, 25.5 cm.; width, 21.3 cm. Dated 1141. Muto Collection, Hyogo Prefecture.*

84. *Underpainting for a sutra on fan-shaped paper.* ▷ *Colors on paper; height, 27.4 cm. Second half of twelfth century. Shitenno-ji, Osaka.*

COLOR VERSUS LINE Art historians have been quick to draw our attention to the marked stylistic differences and sharp contrast seen when the *Genji* scroll is compared with the group of other Heian-period picture scrolls, such as the *Shigi-san, Ban Dainagon,* or *Choju Giga.* The *Tale of Genji* is the very summit of Japanese literature, and the magnificent color and rich feeling of the *Genji* scroll have earned it similar accolades as the high point in the history of Japanese art. The scroll is composed of a series of single pictures, each complete in itself and blending beautifully with the narrative calligraphy that ranges so gracefully over the exquisite *shikishi* paper to either side. This is why, although keeping the characteristic continuity of picture scrolls, the *Genji* can be also appreciated just for each picture. Actually, there are some scholars who claim that the

paintings were originally separate creations that were brought together to form the scroll only at a later date.

The *Shigi-san* group, on the other hand, shows a strong line and light hues (in some cases the light colors are dropped in favor of simple ink drawing, as in the *Choju Giga*) instead of the lush, deep tones of the *Genji*. And in place of the *Genji* scroll's impersonal *hikime-kagihana* approach (abbreviated, one-stroke treatment of eyes and hooked-line nose), its priorities are on personal depiction. There are truly differences in every respect, but it is the *Shigi-san* line above all which is decisive, endowing the work with movement and making the composition thereby the perfect tool to show a temporal progression. While the *Genji* captures quietly the moment, the depths of emotional intensity, the *Shigi-san* group succeeds marvelously in expressing the dy-

namic. The action is limned so well that no explanatory verse is needed. The story unfolds merely by the simple succession of pictures—an almost movielike artistic effect. And the external form of the scroll lends itself perfectly, for it may be unrolled almost endlessly. For the first time, I would say, art began to exploit the unique possibilities inherent in the scroll.

Lessing, the eighteenth-century German playwright and art historian, insists in his *Laokoon* that painting and literary function should be kept completely separate. People of this persuasion might consider the kind of painting that seeks principally to represent temporal progression a perversion. However, it is precisely the fact that they cannot be judged by such rules that gives picture scrolls their unique character. Early creative arts were similarly loath to don a spatiotemporal strait jacket: look at the Buddhist bas-relief of the first century B.C. (Fig. 128) carved in stone on a stupa at Sanchi in India; or the bas-relief in marble on Trajan's Column (Fig. 129) in Rome. Actually, Japan too has the well-known seventh-century miniature shrine called Tamamushi Zushi, preserved at the Horyu-ji in Nara, with lacquer paintings illustrating some of the famous Jatakas (narratives of Gautama Buddha in his many incarnations). The scenes on each of the four sides of the small shrine show an orderly temporal progression. I cannot say whether there is a historical connection between the picture-scroll movement of the *Shigi-san* and these earlier forms; but the masterful, movielike quality of the art as achieved by the *Shigi-san* scroll group by far outstrips anything that had gone before and is furthermore scarcely surpassed in the history of world art.

CHAPTER FIVE

Yamato Painting from the Middle Ages

We noted in the beginning that Yamato painting emerged with the replacement of Chinese with Japanese subject matter. Unhappy copying foreign things never seen, as in the *kara-e* form, the Yamato painters opted for the world of sights and sounds surrounding them—for Japan—and in this rooting of reality lay the significance of the new art form. This meaning may have been largely lost on the persons who commissioned the work or perhaps even the artists who executed it, but it was nevertheless there. In the words she assigns to one of her characters in *The Tale of Genji*, Lady Murasaki pens an extremely clear and telling statement of the artistic significance of painting in the Yamato style.

"We suffer gladly this land of dreams never laid eyes on—the awesome creatures that inhabit the wild deeps, the fearsome beasts that roam the kingdom of China, these faces of devils and hordes of weird fabrications of imagination—so long as they are painted seriously for their never-never kind of surprise. But a scene of mountains, the rush of water, the familiar sights and nearby homes, graced with the lovely lay of land thereabouts, the gentle roll of green, wooded knolls—who cares enough and strives long enough to faithfully render for us these—and with the trees and flowers and all arranged nicely there by the fence—yes, this is really another world, another brushmanship, and no mean talent attempts it."*

Here was indeed a clarion call for artists to forsake the fabulous, the unseen, in favor of the everyday world within one's reach. It is a direct declaration of the reason behind, and the mandate of, Yamato painting.

This places Heian-period painting in the Yamato style somewhat at a distance from the modern realism of the Western art tradition. There is realism of a sort, but the Heian brand was very definitely limited, for Yamato painting did not belong to the people at large; it was the plaything of a minority—the courtiers—and its world was necessarily quite circumscribed.

First of all, we are struck by the limitation of the subject matter. The original audience that produced and appreciated the form was the Kyoto court nobility. The needs of a privileged few in but one sector of Japanese society nurtured the genre. In a real sense Yamato painting could never be the art of the Japanese people. For in order to have a national character, it is not enough that an art is distinguishable from that of other nations. Unless an art is produced and appreciated by the nation

* Translation from the modern Japanese version by Jun'ichiro Tanizaki.

85. Sungyu (Fine Ox). Painting, originally in scroll format. Ink on paper; height, 27 cm.; width, 32.4 cm. Thirteenth century. Tokyo National Museum.

as a whole, it is not worthy of the name "national art." And inasmuch as we cannot equate the Japanese nobility with the Japanese nation, the art of the nobility remains the art of the nobility, not of the nation. Because it held the reins in both the political and cultural spheres during Heian times, the aristocracy prevailed in religion and art, and so, naturally, in painting as well. Admittedly, the songs and festivals that arose on a broad base among the common people had from earliest times had a considerable cultural influence on the isolated nobility. But the luxurious, more sophisticated aspects of painting made it the aesthetic preserve of the elite, and led to the inevitable elitist orientation.

Because the form existed for the nobility, there was a certain polish and exquisite taste about it. On the other hand, cut off as the upper classes were from the outside, prisoners in a privileged

but small sector of society, they necessarily possessed a restricted view and limited awareness that were bound to mark their culture. Anyone who picks up the *Genji Monogatari* or other Heian writing will be struck by the pervasive sense of beauty he finds, as well as dismayed by the walls thrown up by a certain set of thought and life style. This mixed blessing is also found with painting.

Yamato painting, through its Japanese elements and approach, can be justly said to have paved the way for *nihon-ga;* but the term "Japanese," we notice, has finally come down to the Japaneseness of the nobility. The various annual events and the scenery Yamato painting gives us are the reflection of Kyoto's upper-class tastes.

Though I covered earlier the immediate reasons for preoccupation in *yamato-e* with seasonal events in terms of the Japanese climate, more especially that of the Heian cultural matrix, I believe there

86. *Retired Emperor Shijo from the* Rekidai Shin'ei Sekkan Daijin Ei *(Portraits of Emperors and Ministers) picture scroll. Colors on paper; height, 28.8 cm. Thirteenth to fourteenth century. Imperial Household Collection.*

87. *Kakinomoto no Hitomaro, the "god of poetry," from the* Sanjurokkasen Emaki *(The Thirty-six Poetic Geniuses Picture Scroll), Satake version. Colors on paper; height, 36.1 cm. Thirteenth century. Morikawa Collection, Aichi Prefecture.*

is one more reason that is the most radical of all: ancient Japan was an agrarian nation. For a farming people, be it the noble who reaped the fruits or the peasant who worked the land, there was the keenest of connections with the cycle of seasons and events. However indirectly, the nobility did feel the connection, and their art was bound to evoke the link with the round of annual events. That this rich feeling for the seasons grew, and manifested itself in the arts, is the correct view. (I touched on it only in passing, but the screen for the Shinto agricultural festival held after an enthronement had four-seasons paintings on it, indicating a three-way tie among nobility, agriculture, and the seasons.) This is why there are many farm-related

themes in *shiki-e*. The farmer's labors are frequently found, too, but only by way of providing a quaint background—the farmer as seen from the limited viewpoint of the high-living consumer class. Hence, such painting reveals neither sympathy for, nor understanding of, farmers' toil. One *waka* attached to a spring-field painting says it this way:

Tilling spring fields—
 We leave that to others.
And the livelong day
 We spend
Among the cherry blossoms.

As long as the ruling class with its sense of privilege could loll serenely among cherry blossoms, bliss-

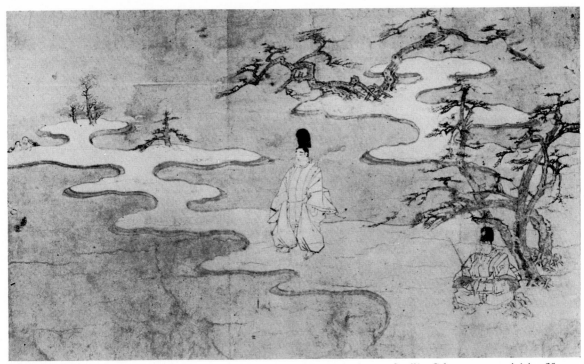

88. *Section from the* Sumiyoshi Monogatari Emaki *(Tale of Sumiyoshi Picture Scroll). Colors on paper; height, 30 cm. Fourteenth century. Tokyo National Museum.*

fully unmindful of the sweat that fell to the common lot, it was only natural that its painting also be structured by this myopic point of view.

Elitist art could attain the utmost limits of sensitivity, creating an art of consummate beauty and sophistication, but let it wander one step beyond its narrow ambit and it proved incredibly ignorant and helpless. For the aristocracy there was only the aimless round of events, year in and year out; power struggles that forgot the good of the people; the gratification of its endless amours; a life colored by the peculiar climate of the Heian capital that was its home. This narrow experience became stifling, eventually impoverishing aristocratic art both as to means and methods. Themes and composition became mannered and, indifferent to fresh subjects and novel approaches, the Yamato form at last looked to nothing new.

TOWARD NEW CULTURAL FORMS

Had Yamato painting been caught in this web forever, it would have been short-lived indeed. Fortunately for Japanese art, however, this cultural situation did not prevail for long. From the late Heian period on, away from the crumbling court government of Kyoto and the dying noble culture, there were fresh stirrings; a different culture was taking shape out in the provinces. New sects sprang up that were nothing like the faith of the aristocrats, who, addicted to a

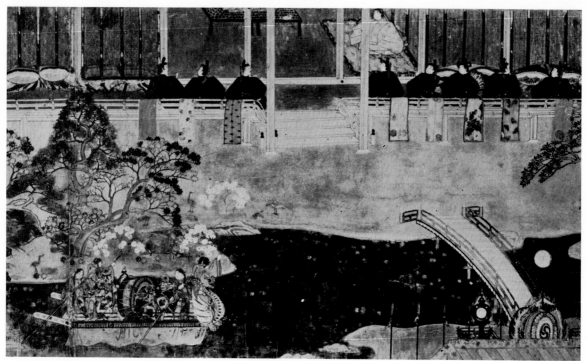

89. *Section from the* Koma-kurabe Gyoko (Imperial Horse Races) *scroll of the* Eiga Monogatari Emaki *(Tale of Splendor Picture Scroll). Colors on paper; height, 33.9 cm. Fourteenth century. Sanjo Collection, Tokyo.*

kind of ecstatic sensuality, built themselves a heaven on earth in the form of temples like the Hojo-ji (Kyoto) or the Byodo-in (Uji). Beliefs brought by various lowly sutra-chanting priests called *hijiri* ("saints") or *shami* ("novices"), or by devotees droning Buddhist invocations, spread among ordinary folk everywhere who earnestly strove for salvation. The creed also caught on with the samurai, who had begun to have the real social power and were contemptuous of a nobility now too enfeebled even to keep the capital free from thieves.

Government by the court, in the new form of rule by cloistered emperors that took over as the eleventh century came to a close, now faced a turning point. Cloistered rule and culture both began to reflect some of these new religiocultural influences I have mentioned, showing that the nobility

could no longer feel satisfied with its traditional stance up till then. This was, indeed, the time of the *Genji Monogatari* picture scroll, which distilled traditional noble sentiment so well and delineated it with so much feeling. On the other hand, the same period also saw the *Shigi-san Engi* type of work, which broadened the art spectrum to include the life of the common people and utilized a powerful, dynamic line that could not have been created out of aristocratic sentiments alone. The contemporaneity of art with two so opposite approaches betokens the change coming over the culture of the period of cloistered rule. As the Kamakura period began, more and more new elements would seep into Yamato painting, resulting in a rich variety and a profusion of paintings. But before moving on to Yamato-style picture scrolls

90. *Section from the* Makura no Soshi Emaki (*The Pillow Book Picture Scroll*). *Ink on paper; height, 25.5 cm. Fourteenth century. Asano Collection, Kanagawa Prefecture.*

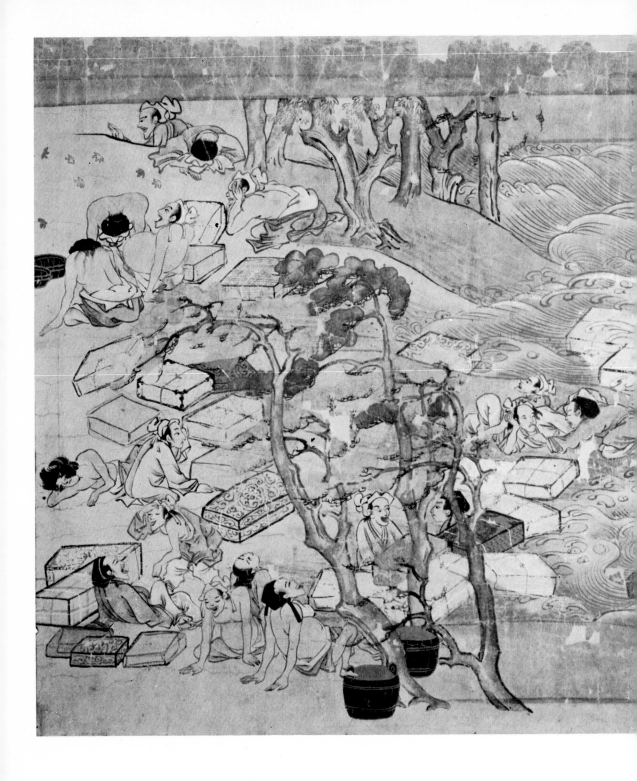

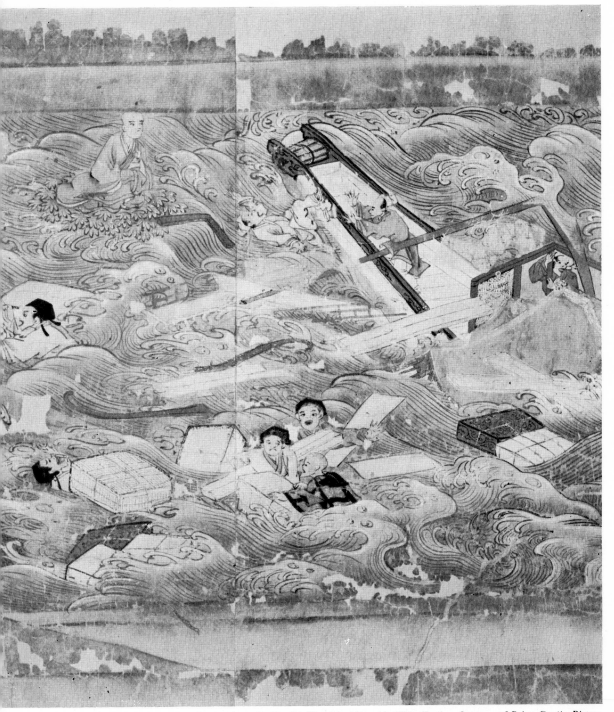

91. *Section from the* Ganjin Toseiden Emaki *(The Eastern Journeys of Priest Ganjin Picture Scroll), by Rengyo. Colors on paper; height, 37.3 cm. Late thirteenth century. Toshodai-ji, Nara.*

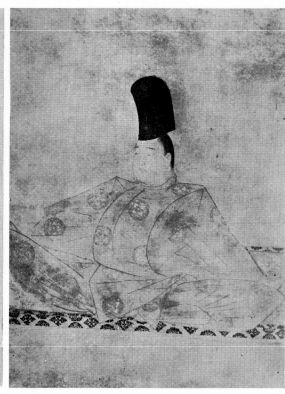

92. *Section from the Zuishin Teiki Emaki (The Imperial Guard Cavalry Picture Scroll). Light colors on paper; height, 28.8 cm. About mid-thirteenth century. Okura Cultural Foundation, Tokyo.*

93. Gotoba-in Zo *(Portrait of Retired Emperor Gotoba), attributed to Fujiwara Nobuzane. Colors on paper; height, 40.5 cm.; width, 30.7 cm. First half of thirteenth century. Minase-jingu, Osaka.*

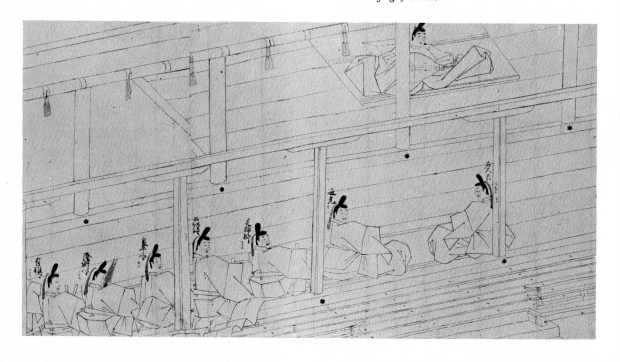

95. *Calligraphic section from the* Yokobue *(The Flute) narrative of the* Genji Monogatari Emaki *(The Tale of Genji Picture Scroll). Ink, color, gold, and silver on paper; dimensions of entire calligraphic section: height, 21.8 cm.; width, 49.8 cm. Early twelfth century. Tokugawa Art Museum, Nagoya.*

◁ 94. *Section from the* Chuden Gyokai Zukan *(Portrait of the Emperor and Courtiers Gathered in the Imperial Palace). Copy, based on the early-thirteenth-century original by Fujiwara Nobuzane. Ink on paper; height, 39.1 cm. Kujo Collection, Kyoto.*

96. *Section from the* Tsurayuki-shu *division of the* Sanjuroku-nin Shu *(Thirty-six Poets' Anthology). Ink and colors over paper collage; height, 20 cm.; width, 31.8 cm. First half of eleventh century. Nishi Hongan-ji, Kyoto.*

97. *Section from the* Ise-shu *division of the* Sanjuroku-nin Shu *(Thirty-six Poets' Anthology). Ink and colors* ▷ *over paper collage; height, 20 cm.; width, 15.8 cm. First half of twelfth century. Yamato Bunkakan, Nara.*

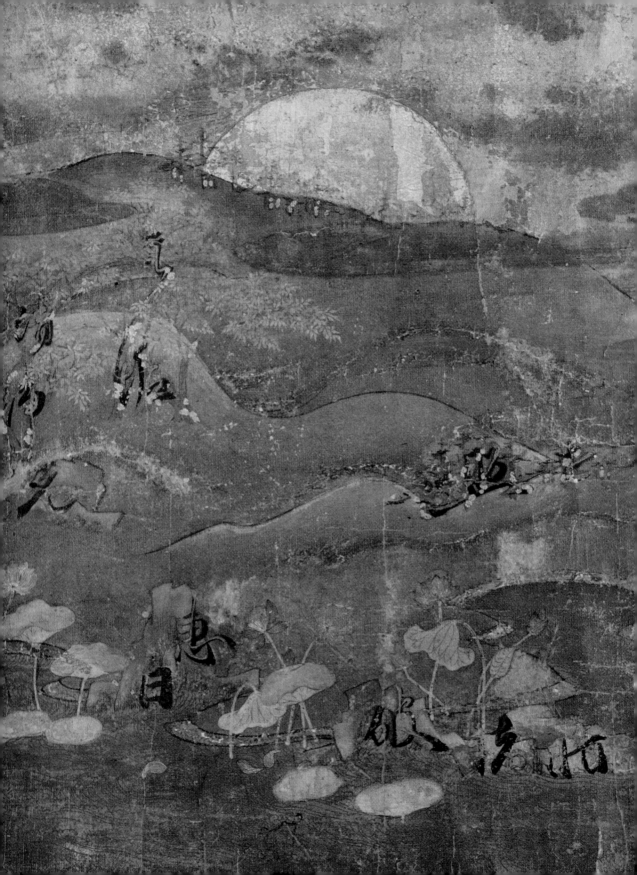

上義一日乃至三七日若出家在家不須和
刀用諸師不白羯磨受持讀誦大乘經典
眼目由是法自出成耐五分法身戒定惠
上用諸善薩助發行故是十方諸佛正法
眼目由是法自出成耐五分法身戒定惠
軒晚軒脆知見諸佛如來徳此法流於大乘
住得受記新走故普於不嚴聞毀破三婦及
上歲八戒比丘戒比丘尼戒沙孫戒沙彌尼戒

說佛依
重法亞次
薩一切諸佛如
賢一切諸佛菩提心則以此
現相繼日發菩提心則以此
妊喜已復更頂相
十方作是言
方等師作是言
方菩薩思方

99. *Example of an underpainting from a sutra in book form* (Kanfugen-kyo; *Dharmamitra Sutra*). *The scene shows Heian-period lords and ladies by a charcoal fire. Colors on paper; height, 15.8 cm.; width, 21.8 cm. About mid-twelfth century. Goto Art Museum, Tokyo.*

◁ 98. *Frontispiece to the twenty-fifth chapter of the* Hoke-kyo (*Lotus Sutra*). *Colors on paper; height, 23.4 cm.; width, 24.2 cm. About mid-twelfth century. Chokai Collection, Tokyo.*

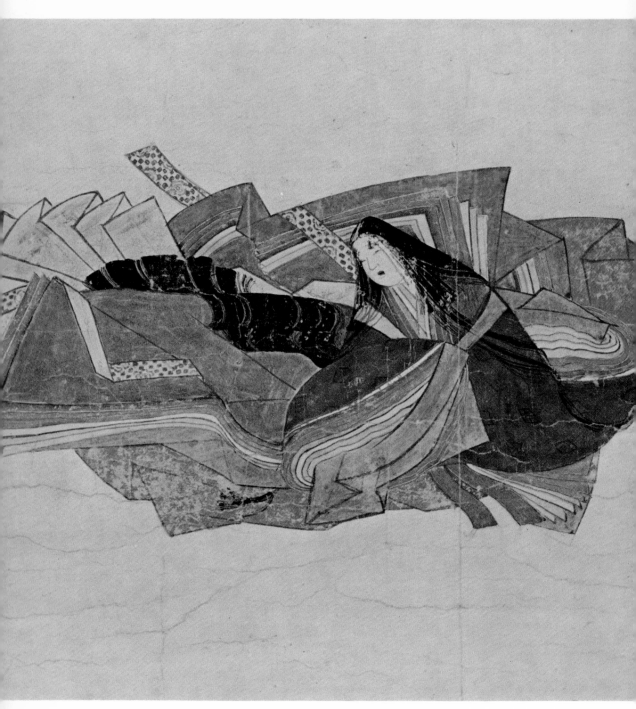

100. The poetess Ko-ogimi, from the Sanjurokkasen Emaki (Thirty-six Poetic Geniuses Picture Scroll), Satake version. Colors on paper; height, 35.7 cm.; width, 59.7 cm. First half of thirteenth century. Yamato Bunkakan, Nara.

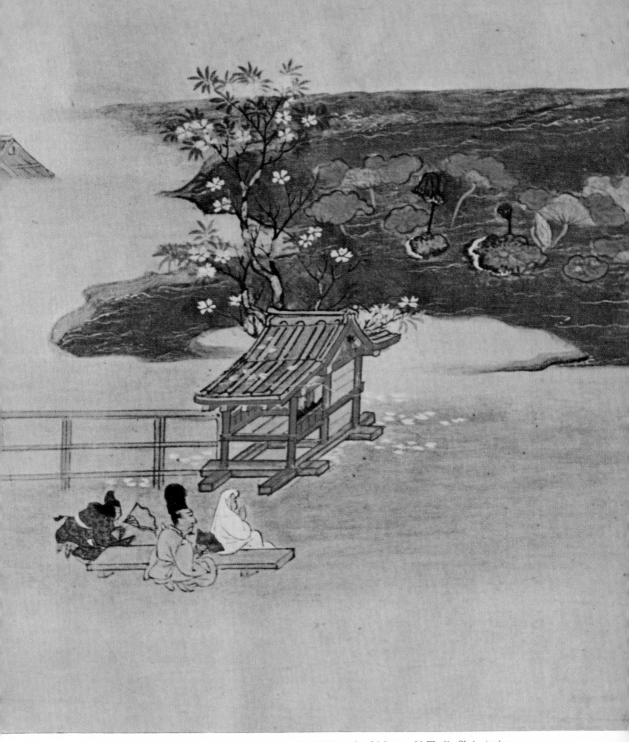

101. Section from the Matsuzaki Tenjin Engi *(Legends of Matsuzaki Tenjin Shrine) picture scroll. Colors on paper; height, 33.9 cm. Dated 1311. Bofu Temman-gu, Yamaguchi Prefecture.*

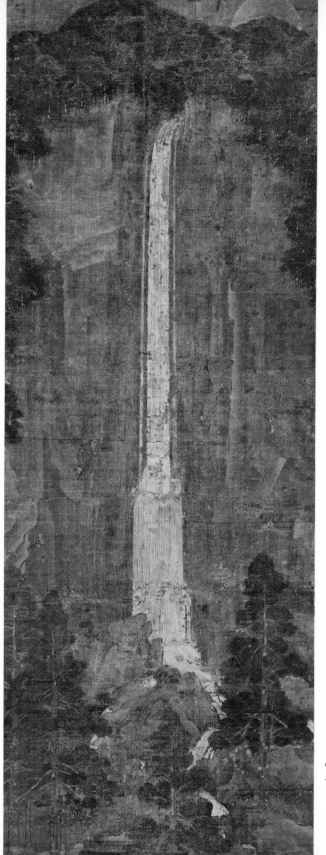

103. Section from the Shui Kotoku-den ▷
(Biographies of Saints Honen and Shinran)
picture scroll. Colors on paper; height, 39.8
cm. Dated 1323. Muryoju-ji, Ibaraki Pre-
fecture.

102. Nachi Falls. *Hanging scroll; colors
on silk; height, 159.4 cm.; width, 57.9 cm.
Late thirteenth century. Nezu Art Museum,
Tokyo.*

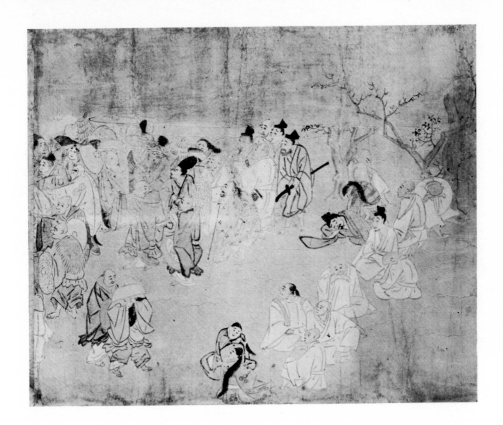

in the middle ages, permit me to devote a few re-marks here to portrait painting.

THE DEMAND FOR PORTRAIT PAINTING

Heian-period painting in the Yamato style is nota-ble for the absence of portrait work. Since portraiture was an important field in China, it is no surprise that we come across in Japan, too, a good number of *kara-e* portraits painted prior to the ninth century, when this form was popular on the continent. A look at the *Portrait of Shotoku Taishi* (Fig. 107), probably dating from the second half of the seventh century, shows there is an obvious similarity with the *Rettei-zu* (Thirteen Emperors) scroll (Fig. 106), traditionally attributed to Yen Li-pen (?–673). The famous T'ang artist's work is surely the prototype. I mentioned earlier that there were a great many portraits of Confucius,

the Thirty-two Sacred Sages, and other historical figures in the *kara-e* medium.

I think it was in imitation of the display of Con-fucius's portrait for the festival in his honor that the similar custom began of hanging the portrait of Kakinomoto no Hitomaro—the celebrated poet and "god of poetry," who died at the beginning of the eighth century—for veneration in conjunction with poetry contests (Fig. 55). So-called Hitomaro portraits appeared as the Heian period drew to a close. This is not to say that figure or portrait painting had been totally absent, but to the aris-tocrats, whose ideal of the treatment of human beings was to be the stereotyped (slit eyes, hooked-line nose) kind of depiction, as found in the *Genji* picture scroll, portraits that attempted to depict human faces faithfully seem to have been distaste-ful. (Faces of commoners in the *Shigi-san* scroll,

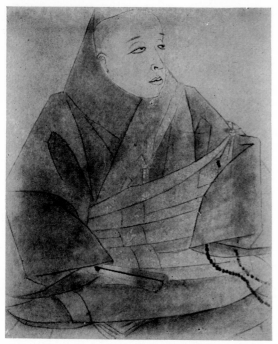

104. Detail from Hanazono-in Zo *(Portrait of Retired Emperor Hanazono)*, by Goshin. *Light colors on paper; dimensions of entire painting: height, 31.2 cm.; width, 97.5 cm. Dated 1338. Chofuku-ji, Kyoto.*

105. Shinran Shonin Zo *(Portrait of Saint Shinran)*, also known as Kagami no Mi-ei, by Sen Amida Butsu. *Ink on paper; height, 39.7 cm.; width, 32.7 cm. About second half of thirteenth century. Nishi Hongan-ji, Kyoto.*

incidentally, are quite individualistic; but upper-class nobles all come equipped with the one-stroke eyes and hooked-line noses.) Which is to say that Heian knew no serious Yamato-style portrait painting. The nobles, having no other ability than that of clinging to their hereditary privileged position, produced no memorable heroes. No need was felt, therefore, to fix the traits and peculiarities of individuals in graphic form, and the fact that the art of portraiture failed to develop must have been due in part to this.

At the end of Heian the civil strife carried over into the great days of reform with the feudal shogunate in Kamakura. Many heroes were made, many hearts were touched. The person and his exploits gave birth to a new literary form of *monogatari*, the military epic, setting off a portrait fad in art. Since objectivity was required so as to ac-

curately depict a person, the so-called *nise-e*, a portrait-painting form in the Yamato style and rooted in realism as a principle, came into existence. Fujiwara Takanobu (1142–1205) and his son Nobuzane (1176?–1266?) became its proponents. The *Minamoto Yoritomo Zo* (Portrait of Yoritomo; Fig. 14) by Takanobu and the *Gotoba-in Zo* (Portrait of Retired Emperor Gotoba; Fig. 93) by Nobuzane, and other portrait work (Figs. 104, 105) based on very faithful portrayal (Fig. 144), were done under the banner of Kamakura-period Yamato painting. It was a new field, one that Heian had never known.

NEW THEMES The spirit of *nise-e*, its search for realism, was not exhausted in the personal-portrait medium. As I stated before, Yamato painting also embraced a certain realistic

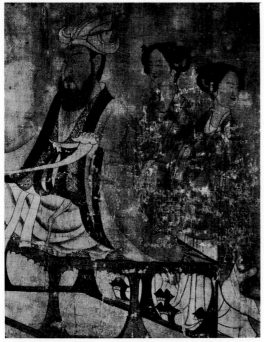

106. Detail from the Rettei-zu (Thirteen Emperors) picture scroll, attributed to Yen Li-pen. Colors on silk; dimensions of entire scroll: height, 51 cm.; length, 531 cm. About 650. Boston Museum of Fine Arts.

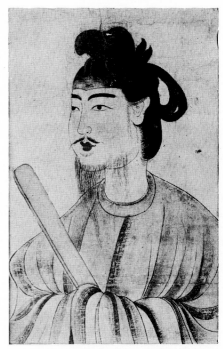

107. Detail from Shotoku Taishi Zo (Portrait of Shotoku Taishi). Colors on paper; dimensions of entire painting: height, 125 cm.; width, 50.6 cm. Seventh to eighth century. Imperial Household Collection.

approach, having originated with the wish to portray ordinary Japanese things. But we saw that this realism was never the kind to confront actual life and then set it down as it was. In the niggardly grip of aristocratic sentiment, what realism there was was severely limited by cramped class consciousness. Vision was impaired from the outset by the smallness of field and congenital near-sightedness.

As the nobility lost their power and the new military class took over, a new day dawned. Yamato-style painting shed some of its medieval attire, reaching out for new subject matter and making creative breakthroughs in regard to methods that would have been impossible before, hamstrung as the Heian nobility had been. Still, the nobility had not completely lost its hold on things that mattered. It held fast to rank, and could yet claim

tremendous cultural achievements, whereas the warrior class could not. Fortunes of the once high and mighty could decline, but the nobility had no need to be utterly disconsolate: their culture had made its mark. Parallel with literary works such as *waka* poetry in the *Shin Kokin* style and tales like *Koke no Koromo* in the style of the old romances, we can find numerous *yamato-e* scrolls in the tradition of *The Tale of Genji* picture scroll. These include *Murasaki Shikibu Nikki* (The Diary of Lady Murasaki; Fig. 46), *Nezame Monogatari* (Tale of Nezame; Fig. 47), *Makura no Soshi* (The Pillow Book; Fig. 90), *Eiga Monogatari* (Tale of Splendor; a rather factual, forty-volume history of two centuries leading up to 1092 and focusing nostalgically on Fujiwara Michinaga; Fig. 89), *Sumiyoshi Monogatari* (Tale of Sumiyoshi; Fig. 88), *Ono Goko* (Imperial Visit to Ono), *Takafusa-kyo Tsuyakotoba* (Love

108, 109 (left and above). Sections from the Ippen Hijiri Emaki *(Biography of Saint Ippen Picture Scroll), by* En'i. *Colors on silk; height, 38.2 cm. Dated 1299. Kankiko-ji, Kyoto.*

Letters of Lord Takafusa), *Nayotake Monogatari* (Tale of a Young Bamboo, also known as *Naruto Chujo Monogatari*), and *Ise Monogatari* (Tales of Ise; Fig. 49).

Despite the continued popularity of works in the old style, a crush of many other new works, led by the *Shigi-san Engi,* with its place for the common people and the way they are dynamically drawn, was already bursting the gates of the narrow aristocratic establishment.

SCROLLS OF THE NEW BUDDHIST SECTS In the transitional phase leading into early Kamakura, a new ensemble of picture scrolls appeared: *Gaki Zoshi* (Scroll of Hungry Ghosts; Figs. 9, 80), *Jigoku Zoshi* (Scroll of Hell; Figs. 44, 78, 79, 137), and *Yamai Zoshi* (Scroll of Diseases and Deformities;

Figs. 45, 76, 77). The group most likely belongs to what has been called *rokudo-e* (literally, "pictures of the six ways"), because the three respective subjects that are treated in these scrolls belong among the six regions constituting the Impure Land of the Buddhist world. The unflinching way in which *rokudo-e* confronted the evil and ugly must have been a shock to the sensitive nobles. It was an unexpected paradox in art that told of a different world in the making. These new Jodo sutra-painting forms found their basis in the teachings of Jodo Shin-shu, the Buddhist creed preached by Shinran (1173–1262), who advocated the overcoming of the evil and tribulations of the tainted present world so as to be reborn in the Pure Land of the next. If one counts the many new Buddhist sects, there is no gainsaying that culture in Kamakura was importantly affected. If nothing else, the new sects

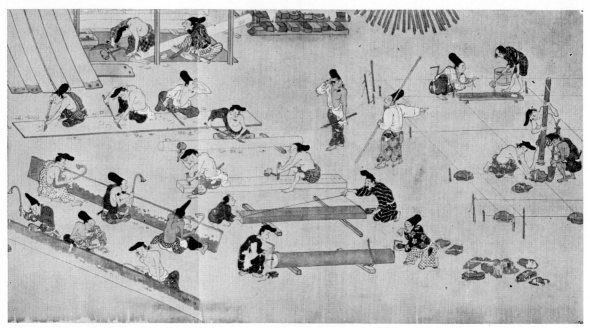

110. Section from the Kasuga Gongen Kenki (The Kasuga Gongen Miracles) picture scroll, by Takashina Takakane. Colors on silk; height, 41.2 cm. Dated 1309. Imperial Household Collection.

brought the faith to the military class and masses, where it had been only court property before. Their rise was the most outstanding sign of the transformation taking place in the culture of the middle ages. Painting would show links with the new beliefs time and again, too. The greatest instance was the *Ippen Hijiri Emaki* (Biography of Saint Ippen; Figs. 53, 108, 109), which has as a theme the missionary travels of the Jishu-sect founder, Ippen (1239–89). He took his gospel to the people, and this scroll develops much more pronouncedly the grass-roots theme seen before in the *Shigi-san* and *Ban Dainagon* scrolls. Another invaluable point: the *Ippen* scroll provides a panorama of the places the zealous founder visited across Japan; the scenery is handled very realistically, sensitively, and one notices that the unreal depiction of Heian-period *meisho-e* has come nearly full circle at this point, thanks to the objective landscape approach in the spirit of the *nise-e*. Now,

for the first time, *yamato-e* is landscape painting in the real sense of the word.

Although they did not reach the high artistic standard of the *Ippen Hijiri Emaki*, we should not overlook picture-scroll biographies of the founders of new sects, since they form part of the domain opened up by Kamakura picture scrolls. Good examples are the Fujisawa version of *Ippen Shonin Eden* (Pictorial Life of Saint Ippen), and pictorial biographies of the priests Shinran and Honen (1133–1212, founder of the Jodo sect; Figs. 54, 147). The earlier forms of Buddhism, too, bristling with reforms from encounter with the new, gave birth to their kind of scroll painting, as is evident in the *Kegon Engi* (Legends of the Kegon Sect; Fig. 52), the *Genjo Sanzo* (Travels of Genjo Sanzo to India; also known as *Hosso Hiji Emaki*; Fig. 56), and the *Ganjin Toseiden* (The Eastern Journeys of Priest Ganjin; Fig. 91) scrolls.

Religion wielded great power at the time, so the

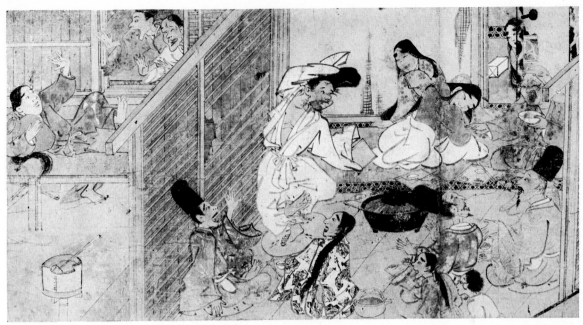

111. Section from the Eshi no Soshi (Story of a Painter) picture scroll. Colors on paper; height, 30 cm. Fourteenth century. Imperial Household Collection.

shrines and temples exerted vast cultural influence. Besides producing pictorial biographies of the famous founders of Buddhist sects, artists also painted great legendary histories of religious places. *Kitano Tenjin Engi* (Legends of Kitano Tenjin Shrine; Fig. 50), *Kasuga Gongen Kenki* (The Kasuga Gongen Miracles; Figs. 28, 57, 110), and *Ishiyama-dera Engi* (Legends of Ishiyama-dera; Fig. 51) are examples. These scrolls employed strong colors, for they sought to stress the depicted miracles. Due place was not only given to the stylish nobility, but to the samurai and the common people as well. They evidence a rich variety of subject matter, an attribute of painting of the middle ages as a whole.

PICTORIAL RECORDS OF THE TIMES Military exploits were lionized in a form in literature called *gunki monogatari* (military tales), and scroll painting was quick to adopt such epics in the *Hogen Monogatari*

(The Tale of the Hogen Rebellion) or *Heiji Monogatari* (The Tale of the Heiji Rebellion; Figs. 48, 58, 113) picture scrolls. Eventually there came a work that amounted to a running depiction of the actual life of a samurai—that of Takezaki Suenaga in the *Moko Shurai* (Mongol Invasion) scroll (Fig. 59).

In addition there were works that brought the popular *nise-e* portrait into the scroll medium, including among them *Rekidai Shin'ei Sekkan Daijin Ei* (Portraits of Emperors and Ministers; Fig. 86), *Chuden Gyokai Zukan* (Portraits of the Emperor and Courtiers Gathered in the Imperial Palace; Fig. 94), and *Zuishin Teiki* (The Imperial Guard Cavalry; Fig. 92) scrolls. Then we have scrolls like the *Sanjurokkasen Emaki* (The Thirty-six Poetic Geniuses; Figs. 87, 100; these are not *nise-e*, as they depict poets who lived long before the Kamakura period, but they also reflected an interest in figure painting), the *Sungyu Emaki* (Fine Oxen; Fig. 85), which

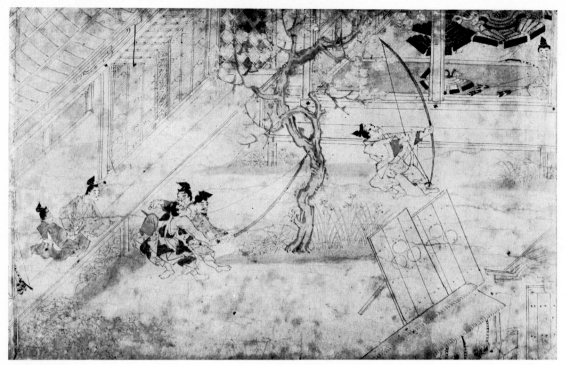

112. *Section from the* Obusuma Saburo Emaki *(Story of the Samurai Obusuma Saburo Picture Scroll). Colors on paper; height, 29.1 cm. Late thirteenth century. Asano Collection, Kanagawa Prefecture.*

might be called "animal *nise-e*," and *Saigyo Monogatari Emaki* (Biography of Priest Saigyo; Fig. 60), which by its novel form breathed new life and feeling into the Heian aristocratic heritage. All in all, a truly wide variety of works in the picture-scroll medium survives from the Kamakura period.

THE YAMATO-E TRADITION IN LATER TIMES
Without doubt, Yamato painting gained a new lease on life in the middle ages. But this flower of aristocratic culture was to bloom brightly only while the court ruled the country. With the swift social upheaval and class reshuffle in the period of the Northern and Southern Courts between 1336 and 1392, when Japan had two rival imperial lines, and thereafter, the fate of the nobility was sealed. Yamato painting

was to fall on bad days. *Suiboku* (ink-monochrome) painting, freshly brought in from China, became the darling of the new classes and this virtually laid Yamato painting to rest.

During the Muromachi period (1336–1568) there still appeared many semihistorical scrolls based on the legends of temples and shrines, which related miraculous happenings, or variations on the popular genre (Fig. 146) of the day, the *otogi-zoshi* (literally, "books of fairy tales"; the generic term for the somewhat moralistic novellas that became very popular at that time), but the techniques began to weaken. It is ironic that the Tosa school, which appeared at this time and claimed to be the heir to the *yamato-e* tradition, was like the last bright flicker of a candle flame before going out. Even in the Edo period (1603–1868), the Tosa

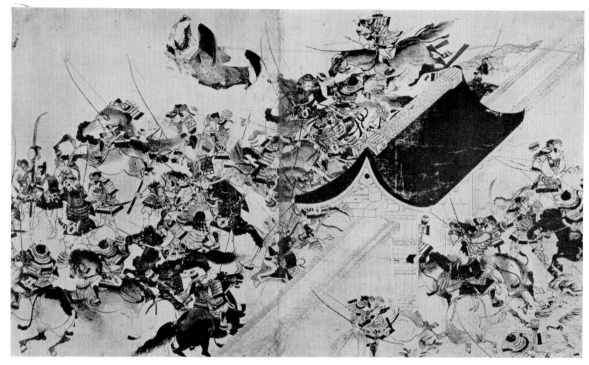

113. Section from the Sanjo-den Yakiuchi *(Storming Sanjo Palace) scroll of the* Heiji Monogatari Emaki *(The Tale of the Heiji Rebellion Picture Scroll). Colors on paper; height, 41.2 cm. Late thirteenth century. Boston Museum of Fine Arts.*

school maintained its position as leader of the *yamato-e* tradition, and preserved the tradition in a small corner of the world of painting. In reality, however, this could not be called a continuation of the *yamato-e* of the ancient period.

As a historical genre, Yamato painting finally died in the Muromachi period. Its spirit, however, lived on in a new painting genre that swept the Japanese art scene. With the Kano school of late Muromachi came an entirely new approach that blended the Yamato style with ink painting. In the first half of the seventeenth century, the great Tawaraya Sotatsu transformed the rich Yamato legacy into yet another new form—the decorative painting style. Then, in ukiyo-e woodblock art there were even artists who referred to themselves as "painters of the Yamato style"; and, in some

sense, they belong to the tradition. The later landscapes of the woodblock artist Ando Hiroshige (1797–1858) and his group revived the old standby of Heian Yamato: the union of man and nature through the depiction of seasonal things and people (Fig. 151).

Finally, twentieth-century *nihon-ga* makes it clear again that many artists still dip their brushes into the *yamato-e* wellsprings of the ancient and medieval periods (Fig. 152). A millennium has come and gone, but the inexhaustible legacy of *yamato-e* lives on as ever in Japanese painting history.

It was the disenchantment with the new but unreal landscapes, customs, and tales of another land that led Yamato painting to depict actual Japanese life and people in depth. And this in turn naturally led

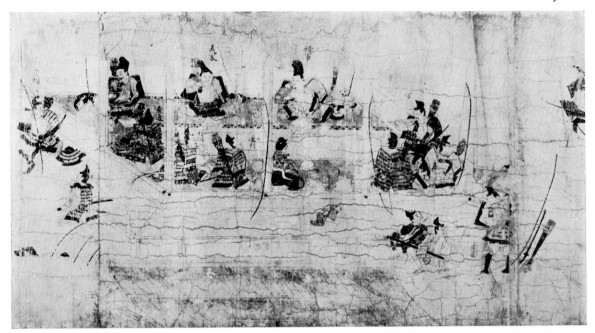

114. Section from the Zen Kunen Kassen Emaki *(Nine Years of War Picture Scroll). Colors on paper; height, 30.6 cm. Fourteenth century. Tokyo National Museum.*

to the real significance of *yamato-e* as the record of one particular period of Japanese life—a record one can actually look at. As art, of course, it must be judged on the basis of its worth as artistic expression. Historical value is, admittedly, something else. Nevertheless, even aside from aesthetic considerations, *yamato-e* is of priceless historical value because it sets down concretely before us a page from centuries past. I can see no reason to judge a cultural legacy such as Yamato painting purely from the viewpoint of art in the strict sense.

The gradual broadening of outlook Yamato painting showed—shrugging off the aristocratic encapsulation of Heian times, then enlarging its view up through the days of the *insei* administration and the Kamakura period—ultimately endowed it with great historical value in the process.

In the end, no matter how many documents one gathers for reference, the reach into the past is always for something sadly beyond our grasp. We are indebted to Yamato painting, in the gratifying number of picture scrolls in which it survives, for a remarkable close-up of life as it was a thousand or so years ago. These flashbacks tell us of those who lived in Japan during the ancient and medieval periods. Picture scrolls are the "documentary movies" of those times—and in color, at that. Perhaps this is also the best angle from which to grasp the meaning of Yamato scroll painting today. It is my hope, as you page through this book for the beauty and interest of these paintings as art, that you might pause, if only a moment, to view these scrolls for the large slice of living history they present in such a lively way.

CHAPTER SIX

Yamato Painting:
A Detailed Study

THE BEGINNINGS OF JAPANESE PAINTING The earliest evidences of our Japanese ancestors' inclination to draw are found in Yayoi-period (second century B.C. to third century A.D.) earthenware, in relief pictures on some *dotaku* (bronze bell-shaped ceremonial objects), in the burial-cave engraved murals (Fig. 1), and the relief work—hunting or family-crest designs—on the backs of bronze mirrors.

These simple, unskilled works that appear on the very first page of Japanese painting history, despite allowance for the primitive quality, do not suggest a direct link with subsequent brush painting; and the mirrorwork actually belongs to a later sculpture category. Nevertheless, such humble beginnings may be understood as the origin and earliest form of Japanese painting. The murals in the burial mounds in Kyushu include simple, stylized designs, but among them are depictions of animals, human figures, and various utensils (Fig. 2) that would fit in with modern definitions of painting. And if we accept that they were influenced by Korean funerary paintings (Fig. 3), they represent the first step in the transplanting of painting techniques from the continent.

Although primitive work like this found among archaeological objects would not seem to have a direct historical connection with the painting on paper or silk that began in the seventh century, the fact that it amounts to an attempt to depict man's life as it really was—something in common with the realism of later Yamato-style painting—is very interesting. The engraved murals on the walls of the grave at Takaida in Osaka (Fig. 1) show people first in a boat, then on land, all in the same scene. This approach, employed to denote a progression in time, is the same as the movielike technique we find in the street-fighting scene (Fig. 10) in the *Ban Dainagon* picture scroll. The similarity with the action aspects of later scrollwork may be coincidental; then again, there just might be a prototypical relationship. If one discovers in primitive artworks such as these the germ of the special characteristics of *yamato-e*, then the conclusion follows naturally that the form originates with them.

Although Yamato painting may be traced to historical beginnings in Yayoi or Tumulus times (second century B.C. to sixth century A.D.), the more immediate matrix was the Chinese painting (inclusive of Korean painting in Chinese style) introduced systematically into Japan in the seventh century. From that time on, imported paintings, or copies thereof, in the Chinese *sezokuga*, or secular painting, style—which is to say, *kara-e*—laid the immediate foundations for Yamato painting.

The oldest of these secular paintings in Chinese

117. Araumi *(Wild Sea) panels, from the nineteenth-century publication* Hoketsu Kemmon Zusetsu *(Pictorial Views of Imperial Sites).*

115 *(left). Panels showing saints and sages, depicted in the* Nenju Gyoji Emaki *(Picture Scroll of Annual Rites and Ceremonies).*

116 *(below). A panel showing Lake K'unming, depicted in the* Ban Dainagon Emaki *(Story of the Courtier Ban Dainagon Picture Scroll).*

style is the *Portrait of Shotoku Taishi* (Fig. 107), thought to be a work of the latter part of the seventh century. It was modeled after Yen Li-pen's handscroll *Thirteen Emperors* (Fig. 106), which is typical of T'ang portraiture. In any case, seventh-century *sezokuga* are scarce, extant examples of real *kara-e* dating mainly from the eighth century onward. The Shoso-in collection of Emperor Shomu's favorite art objects contains figure painting (Fig. 17), some genre paintings with landscape (Figs. 6, 7), and *kachoga* (bird-and-flower painting). All of these show *kara-e* with considerable variation. Besides the screen panel *Lady Under a Tree*, there are paintings on *biwa* lutes and on pottery. These may be mere decoration for handcrafted objects, but the gorgeous color and majestic landscape we see in Figure 7 are an invaluable source for reconstructing the appearance of *kara-e* landscape screens, of which not a single one is extant.

Although many of the *kara-e* in the Shoso-in are thought to be imports, records show that from the

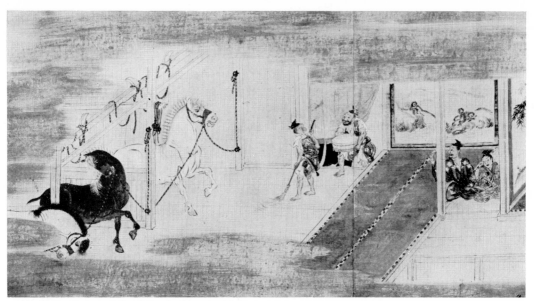

118. *Section from the* Seiko-ji Engi *(Legends of Seiko-ji) picture scroll, by Tosa Mitsunobu. Colors on paper; height, 33 cm. Dated 1486. Tokyo National Museum.*

ninth century various kinds of *kara-e* were also painted in Japan. Most of these are lost, but there are late-Heian scrolls that depict panels in the Imperial Palace in Kyoto decorated with paintings of Chinese saints and sages (Fig. 115) and Lake K'unming (Fig. 116). A nineteenth-century publication shows the *Araumi* (Wild Sea) panels (Fig. 117), and Figure 18 the portraits of Confucius and his disciples hung at the imperial school of higher learning. The problem remains, of course, as to whether or not these "made-in-Japan" versions are faithful to their prototypes; nevertheless they are generally helpful for an insight into *kara-e* as it was in early Heian times. The only remaining example from the period is the Chinese-style figure painting shown in Figure 16. I think the reader would agree, from a look at the exclusively Chinese figures and non-Japanese landscapes that these show, this is hardly genuine Japanese art. On the other hand, among later picture scrolls, there are quite a few works, like the *Heike Nokyo* frontispiece

(Fig. 12) or the *Kegon Engi* (Fig. 52) scroll, that include *kara-e* style motifs or depictions of such fabulous subjects as the Palace of the Dragon King. Even when Japanese landscapes are treated, there is often a partial use of the techniques of *kara-e* landscape painting. Thus *kara-e* looms surprisingly large in Yamato painting, and we have to recognize its historical importance as the source from which *yamato-e* sprang.

A clear understanding of the rise of *yamato-e* requires knowledge of the history of painting in T'ang China. Paintings of that period barely survive, however, and the prosperity the T'ang form saw, as indicated by other sources, is pathetically difficult to corroborate with extant art. There are only a few examples left in China for us to work with, although some indirect help is provided by paintings from among later Chinese work. Oddly enough, it is our seventh-, eighth-, and ninth-century *kara-e* in Japan that offer the little light on the subject there is to be had.

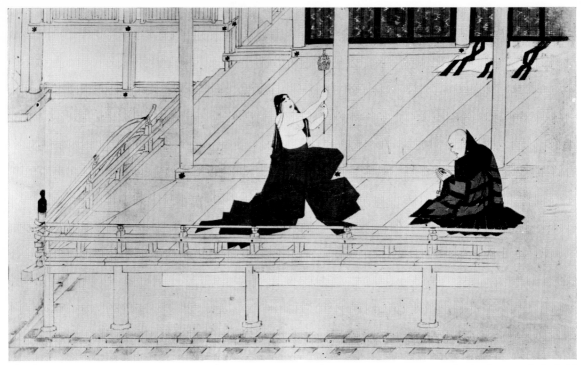

119. *Section from the* Matsuzaki Tenjin Engi *(Legends of Matsuzaki Tenjin Shrine) picture scroll, showing a seminaked girl dancing and chanting. Colors on paper; height, 33.9 cm. Dated 1311. Bofu Temman-gu, Yamaguchi Prefecture.*

Figure painting has fared hardly better with time, and except for a single landscape, one scene in Ku K'ai-chih's *Illustrated Admonitions of the Court Steward* (Fig. 20), dating from Eastern Chin (317–420)—and this is not really landscape in the literal sense—almost nothing comes down from T'ang or before. The Tunhuang murals alone must serve as a source for whatever is to be known of real T'ang landscape work. All this means that our search for the basis of nature painting in *yamato-e* is crippled by having to grope along with scattered Chinese nature paintings, none of which are landscape work in the true sense.

But here we might join Japanese archaeologists in turning our attention to the interesting murals of Inner Mongolia in the imperial tomb of Yung Ch'ing of Liao (947–1125). Dating from the first half of the eleventh century, these murals show separate scenes of the four seasons with a sprinkling

of local surroundings added (Fig. 21). One begins to wonder: could this be how Yamato *shiki-e* screen painting began? Perhaps two painting styles were heir to Chinese landscape painting in different forms—the Yamato of Japan and the mural type of Mongolia—each of them an art of no mean sophistication. The thought that the Japanese and Mongolian painting styles are the offspring of T'ang-dynasty painting is interesting, to say the least.

As I mentioned earlier, the process by which *yamato-e* came into being in the second half of the ninth century cannot be reconstructed from the extant works of that period available to us. However, we do have some materials indicating that a Japanese type of painting that was eventually to lead to the appearance of *yamato-e* was already burgeoning as early as the eighth century, when *kara-e* still had the field to itself.

120. Dai Dairon *(The Big Con-
troversy). Cartoon sketch from a
bound book. Ink on paper; height,
19.5 cm. About mid-eighth century.
Shoso-in, Nara.*

*121. Doodles on the ceiling of the
Golden Hall of the Horyu-ji, Nara.
Ink on wood. Late seventh to early
eighth century.*

*122. Doodles on the pedestal of a
statue in the Golden Hall of the
Toshodai-ji, Nara. Second half of
eighth century.*

*123. Doodles in the Phoenix Hall
of the Byodo-in, Uji. Ink on wood.
Dated 1053.*

124. *Detail from a map in a bound book. Ink on paper; dimensions of entire map: height, 28.6 cm.; width, 51.9 cm. Dated 758. Shoso-in, Nara.*

An ink landscape painted on hemp (Fig. 22) in the Shoso-in dates from about this time and is not Chinese work. Is this not the first Japanese landscape attempt, feeling its way, as it were? Also around this period, we notice many maps made for practical purposes. They were not the abbreviated kind we have today with only symbols and legends. Mountains, waterfowl, and many different kinds of buildings were incorporated. In short, such maps were a form of landscape painting (Fig. 124).

Even in Heian times an artist's work did not consist merely of painting for aesthetic purposes. A share of maps and design work was an important part of his job. And since these landscapelike maps also consumed artistic energies in the eighth century, it is difficult to believe their production would not affect development of landscape painting as art.

If it is true that Yamato painting resulted from the preference for Japanese scenery and Japanese people over Chinese scenery and Chinese people, then these maps, which specifically set down Japanese topography, are—so long as considered as painting—Yamato painting by definition. Maps,

in other words, were the earliest form of *yamato-e*.

Another interesting light on Yamato beginnings is shed by the graffitilike doodles (*rakugaki*) done by artists of the seventh and eighth centuries. Examples of figures and animals done in this cartoonlike way may be seen in the Horyu-ji and Toshodai-ji and in the Shoso-in (Figs. 120–23). The artists obviously drew their ideas from daily life, which means this is surely not *kara-e*. I shall deal with the *giga* (cartoon) form as the ultimate source of the dynamic nature of picture scrolls later.

FOUR-SEASONS
PANELS AND
SCREENS

The tremendous volume of four-seasons (or in other words, famous-place) painting on screens and panels, beginning with the ninth century and extending to Kamakura times, can only be ascertained from the great number of extant *waka* poems. The panels and screens are now lost, but the *waka* remain. They used to be written on *shikishi* paper and pasted on the screens and panels, exquisitely complementing the contents of the painting.

Quite a few screen paintings may be seen in the *Genji* picture scroll, but none appear to belong to the four-seasons kind. A supposed Heian work, the single remaining panel of a *senzui byobu* (landscape screen; Fig. 26), formerly at the To-ji temple, belongs to the *yamato-e* tradition as far as the landscape is concerned. The depicted figures, however, distinctly Chinese in flavor, seem to be in the *kara-e* tradition. Moreover, it cannot be called a four-seasons painting. The screen was used for the *kanjo* initiation rite of esoteric Buddhism, as was the *senzui byobu* at the Jingo-ji temple (Fig. 27). Although the latter dates from as late as the Kamakura period, it has more of the four-seasons touch of Heian-period screenwork.

The door paintings of the Phoenix Hall at the Byodo-in in Uji were originally Buddhist in aim. Still, the more one gazes at them, the more Uji-like the scenery looks, so real, so Japanese is the handling of the landscape (Fig. 25). Although we are bereft of the screens and panels that were everyday Heian decor, these superb natural depictions in the Yamato style provide a single, priceless source from the period. What is more, each door depicts a season, making perfectly justifiable their inclusion in the four-seasons genre. Unfortunately, the peeling is advanced, making surmisal of the original state most difficult. But there is an Edo-period copy by Tanaka Totsugen (1767–1823) that has fared much better, leaving a good indication of the originals.

The *Kasuga* picture scroll has one scene of the interior of a nobleman's residence showing panel work all around decorated with four-seasons paintings (Fig. 28). It is a work of the very early fourteenth century, so we must take this for Kamakura life style. One can make out paintings of the uprooting of young pines at New Year, blossom viewing, and falcon hunting—again, all compositions of the four-seasons type, offering precious insight into what *yamato-e* on sliding panels were really like. In the same way, there are several seasonal panels tucked away in the *Saigyo's Deeds* scroll (Fig. 24) as executed by the master of decorative painting, Tawaraya Sotatsu. It is a reproduction, of course, and datable from the early Edo

period, but the models belonged to Kamakura times. That Sotatsu was faithful to the original compositions—at least as far as the elements he included—may be gathered by comparison with other examples.

Various four-seasons themes can be sampled by a look at the plums or *susuki* (Japanese pampas grass) seen in the *Genji* picture scroll; the deer of the *Shigi-san;* the willows, wells, or autumn fields of sutra fan-painting; or the subjects of the underpaintings on *shikishi* paper. *Meisho-e,* or famousplace painting, as mentioned before, is basically of the same nature as four-seasons painting, and so it need not be considered separately. However, I might suggest the "Osaka Barrier" scene from *Genji,* or, from the Kamakura period, the scenery of Sumiyoshi in the Satake version of *The Thirty-six Poetic Geniuses* scroll as quite suggestive of what *meisho-e* was like in Heian times.

YAMATO-E ARTISTS In the seventh and eighth centuries, when mainland painting techniques were brought to Japan, Japanese artists of Chinese descent, in the service of the imperial court, were required to undertake the systematic study of these techniques. Their main task was Buddhist-theme painting in conjunction with the founding of new temples and the decorative work for monasteries. They worked shoulder to shoulder with, and had no more status than, the carpenters or Buddhist-image makers. The work was broken up into certain operations conducted in very mechanical fashion that left little room for the artist to show his originality.

This situation in the early history of painting created an image that was to die hard: the painter's social standing remained frozen for years. With Heian times, priests of high standing began to take up the brush in Buddhist painting; and from the lower-class public servants, some, like Kudara no Kawanari (782–853), rose to the rank of an eminent artist, famous for his accomplishments with both brush and sword. Kose no Kanaoka (early Heian period) also added luster to the occupation, and gradually painters began to be considered individual artists. But the old Nara-period attitude,

125. *Section from the* Kitano Tenjin Engi *(Legends of Kitano Tenjin Shrine) picture scroll. Colors on paper; height, 51.5 cm. Second half of thirteenth century. Kitano Temman-gu, Kyoto.*

treating them as workers for a job to be done, still clung to them. The painter was certainly not awarded the place of our artist today.

In the social order of the ancient period, the ruling classes looked for people who could produce what they required and be self-sustaining in their service—a productive kind of slavery, if you will. Or then again, the upper class simply wanted things produced for their own amusement. The yield from either motive was considerable. This situation was also true of painting, and the little freedom the painter had as artist finds its reason here. Another peculiarity with Yamato painting involved certain customs of the nobility. Just as aristocratic lords and ladies wrote their own *waka* and other verse, some took to doing their own brand of painting. Emperor Kazan (r. 984–86) and a few others went down in history for their painting skills.

All in all, however, we know few names of artists who were responsible for Yamato-style paintings. Of Kamakura-period scrollwork we have the names, for example, for the *Kasuga, Ippen Hijiri,* and *Ganjin* scrolls, but in Heian-period scrolls there are virtually none for which the painter can be ascertained. *Genji, Shigi-san,* and *Scroll of Hell* are history's greatest assemblage of paintings in the scroll medium, but we do not know who painted them—an indication, perhaps, of the low social position occupied by the Heian painter.

The great names of Kawanari or Kanaoka, or of artists given special mention as having painted when the Yamato form reached its perfection—Asukabe no Tsunenori or Kose no Hirotaka, a disciple of Kanaoka—are not to be found on any extant art. Just one famous Yamato painter, Fujiwara Munehiro, leaves his name on the *Zemmui Dainichi-kyo Kantoku Zu* (Subhakarasimha's Vairocana Sutra Inspiration; Fig. 139), a Buddhist painting with secular elements.

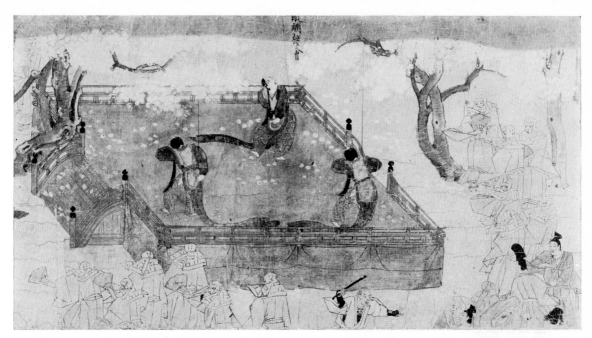

126. *Section from the* Tengu Zoshi *(Stories of Conceited Priests) picture scroll. Colors on paper; height, 29.4 cm. Late thirteenth century. Tokyo National Museum.*

PICTURE SCROLLS AND BOOKS We have many examples of paintings based on *mono-gatari* romances, but they are neither unusual nor confined to a certain form. Painting in scroll form was picked up from China; it did not originate in Japan. But as in the *Shigi-san* or *Ban Dainagon*, the horizontal scroll, with the scenes developing progressively in movielike fashion, is an art form unique to Japan. The bas-relief on Trajan's Column (Fig. 129) in Rome or the Buddhist bas-relief on a stupa at Sanchi (Fig. 128) in India were reaching for the same effect, but they do not compare with the superlative *Shigi-san* scroll.

Were it merely a matter of temporal sequence shown in a single scene, as I mentioned before, we have the burial-cave engraved murals (Fig. 1) of the Tumulus period, or the paintings of the Tamamushi Shrine at the Horyu-ji. But these are not art forms specifically created to express a progression in time. Looking at the *Shigi-san* or *Ban Dainagon*

scrolls, on the other hand, is something like watching a silent movie: they succeed with an effect that is entirely new, something never seen before—the gradual revealing of a series of pictures in scroll form.

The picture scroll is the artistic union of painting and literature in picture "book" form. But it is not the usual picture book where illustrations are subservient to the story. In the case of the *emakimono*, the illustrations are essential to the life of the book.

This characteristic is not the monopoly of the scroll form, but is shared by some books of the bound form, also. Illuminated manuscripts such as those of medieval France and Persia come to mind. Japan, too, had its own beautifully illustrated *so-shi-e* books, some of them containing sutras (Fig. 90). Later on I shall return to the subject of the illustrated Japanese literature that appeared even after Yamato-style scroll illustration had died, and

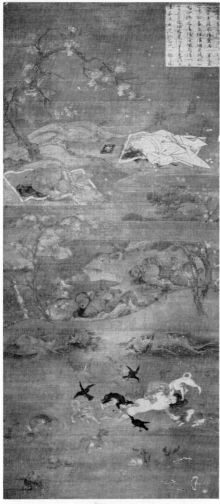

127. Jikkai-zu (*Ten Realms of Living Beings*). *Hanging scroll of the rokudō-e (six regions) type. Colors on* ... *height,* 55.5 cm.; width, 68.2 cm. Late ... *to early fourteenth century. Shoju Raigo-ji, Shiga Prefecture.*

that never failed to include pictures as an essential constituent. Late-Heian and Kamakura scroll and book illustration, however, was incomparable art; nothing before or since has approached it for quality.

Many *emakimono* are extant from the end of the ancient period to the middle ages, and if copies are included, the number grows even more. A sampling of the most representative among them is listed in the Appendix.

THE GENJI MONOGA-
TARI AND THE SAN-
JUROKU-NIN SHU

The *Genji Monogatari* scroll (Figs. 8, 29, 30, 36, 37, 40, 41) provides a brilliant contrast to the scrolls of the *Shigi-san* group. It relies on beautiful color to convey delicate feeling, threading together a series of pictures, each of which has a quiet finality of its own. I would like to draw the reader's attention not simply to the beautiful painting in the *Genji,* however; there is also the magnificent calligraphy (Fig. 95) and the expert craftsmanship of the exquisite *shikishi* paper over which the narrative flows. All three are a culmination of the respective techniques. The *Genji* scroll was intended to be a masterpiece combining these three fields: painting, calligraphy, and papercraft. (And—I might add—literature, because *The Tale of Genji,* itself an outstanding piece of literature, was the basis for the scroll. Hence, it is a combination of three graphic arts plus the field of literature.)

I mentioned earlier a pattern: painting becoming Japanized and *yamato-e* originating; and, parallel to this, writing becoming Japanized and the *kana* syllabary materializing. In addition, the brush-written style of Chinese characters was Japanized. The resulting cursive *so-gana* developed into a superb calligraphic style (*wayo*) completely distinct from the Chinese (*karayo*). Thus the writing in the *Genji Monogatari* scroll is more than explanation, which makes the scroll a lovely *pas de deux* of elegant Japanese calligraphy and Japanese painting in the Yamato style. Also compelling admiration is the wonderful way in which the verse is enhanced and exhibited to the fullest by the

splendidly crafted *shikishi* paper that gracefully links the paintings.

I am reminded of the Nishi Hongan-ji version of the *Sanjuroku-nin Shu* (Thirty-six Poets' Anthology; Figs. 69–71, 96, 97, 133), which also dates from about the same time as the *Genji*. It does not pertain to the scroll- or *monogatari*-illustration category, of course, but it is another breath-taking combination in kind: verse exquisitely written in flowing, cursive style, magnificently made *shikishi* paper, and the Yamato underpainting here and there rounding out the whole. Again, there is the incomparable union of three great fields.

DECORATED SUTRAS A similar fusion of the arts was attempted in the copying of sacred scriptures. In the seventh century a host of venerable monks vied with one another to copy the precious sutras to be used in Buddhist veneration. High personages of the late Heian period (897–1185) exercised their strong artistic prerogatives in this sphere too, in the hope that the beautiful *shikishi* paper designs, frontispieces, and underpainting they had seen brought to perfection in the tale and verse mediums might be luxuriously realized with sutras.

The threefold combination found in the *Genji* scroll and the *Thirty-six Poets' Anthology* was transferred to the sutra-painting idiom and resulted in such beautiful works as the frontispiece to the *Kunoji Kyo* (Kuno-ji Sutra; Fig. 83) dated 1141; that for the *Hoke-kyo* (Lotus Sutra; Fig. 98) in the Chokai Collection; the frontispieces and underpaintings of the thirty-three scrolls of the *Heike Nokyo* (Heike Dedicatory Sutra; Figs. 12, 73, 75), presented by Taira Kiyomori and the Taira clan (Heike) as a pious offering to the Itsukushima Shrine in 1164; the frontispiece to the *Ichiji Rendai-kyo* (Lotus-decorated Lotus Sutra; Fig. 135) in the Yamato Bunkakan; and the underpainting for the *Kanfugen* (Dharmamitra) sutra books found in the Goto Art Museum in Tokyo. There are also some underpaintings for sutras on fan-shaped paper (Figs. 13, 72, 84), such as those of Shitenno-ji temple, most of them depicting customs and manners bearing little or no connection to the scriptures whatsoever.

128. Bas-relief on a Buddhist stupa. Sandstone. First century B.C. Sanchi, India.

129. Bas-relief on Trajan's Column. Early second century. Rome.

Though going by the name of stutra paintings, these contain scenes from *Tales of Ise* and *The Tale of Genji* and thus could be regarded as *monogatari* illustrations. Unlike the *Genji* picture scroll and the frontispieces of other sutras, which show only the lives of the nobility, these works also give wide coverage to the lives of commoners. We almost have the impression that we are looking at a report on Japanese society at the end of the ancient period.

These paintings are all in rich colors, but there are also works such as the *Chuson-ji Kyo* (Chuson-ji Sutra; Fig. 150) of 1117, done with gold-and-silver paints on paper dyed dark blue. The one monochrome sketch of a *monogatari* scene in the *Menashi-kyo* ("Featureless Faces" Sutra; so named because some faces in the underpainting have no eyes, nose, or mouth; Fig. 134), certainly dating from sometime before 1175, reveals that sutra paintings without color existed, too.

THE SHIGI-SAN SCROLL TRADITION

The *Genji* picture scroll distills perfectly the aristocratic sensibilities of Heian art. The work dates from the early twelfth century, when Japan was under the rule of the cloistered emperors, and the long and illustrious hegemony of the Fujiwara clan was on the wane. Yet it is not surprising that the unique characteristic culture of the Fujiwara period should find its most concentrated expression in this period.

If the *Genji* scroll held up the mirror so admirably to the culture during the *insei* administration, there were nevertheless changes under way from its kind of culture to a more open one, brimming with the life of the common people. This other side of the times is best expressed in the *Shigi-san* picture scroll (Figs. 11, 31, 32, 38, 39, 63, 64), which tells of the miracles connected with the priest Myoren.

Many scholars, noting its distinctive line drawing as opposed to the color of the *Genji*, felt the *Shigi-san* style had taken its original lessons in the esoteric Buddhist school of icon sketching. From there the suggestion followed that the scroll was in the tradition of the Tendai-sect priest and painter, Toba Sojo (1053–1140; also known under the name of Kakuyu), which would be making it the art of a painter in the pure Buddhist tradition. But lately the line of reasoning has changed: the meticulous care for court portrayal, among other things, would suggest not a Buddhist painter using Buddhist techniques as much as a court-commissioned artist employing orthodox Yamato-painting methods.

The *Shigi-san* scroll contains a generous sprinkling of humor in the depiction of people and other subjects. This is its trademark and *raison d'être*.

The cartoon tradition dates back to the earliest of drawing techniques. Sketched next to the sutras in one of the bound books of the Shoso-in dating from 745 is the figure of a man arguing, entitled *Dai Dairon* (The Big Controversy; Fig. 120). And from the eighth century there are doodles on the ceiling (Fig. 121) of the Golden Hall of the Horyu-ji, and on the pedestal (Fig. 122) of the Golden Hall of the Toshodai-ji. Dating from later, around the ninth century, are some scribblings on fragments of the Mandala Shrine at Taima Temple. The recently discovered figures (Fig. 123) sketched on the door boards of the Phoenix Hall at the Byodo-in also date from Heian times. All of this is taken as the aimless art of a professional painter passing the time while engaged in some task or other. The powerful ink strokes for the forms of figures or animals show the vigorous line work that was the stock in trade of the *yamato-e* repertory.

Heian-period documents mention tenth-century Emperor Kazan and his skill at *ate-e* (a kind of *giga*), and the monk Gisei, famous for his "expert *oko-e*" (a caricature form that preceded *giga*), which leads us to believe that this kind of *giga* probably evolved into a recognized painting genre. Cartoons that show carts with wheels turning, or scenes with bowmen's arrows speeding toward the mark, are mentioned also. This predilection for movement is much the same in the *Shigi-san* scroll form, and so the latter's historical origins are evidently traceable to the cartoon genre.

NEW HISTORICAL TRENDS

The large amount of Heian painting in the Yamato style must have shown considerable variety both as to form and subject matter. And such variety must have had inherent

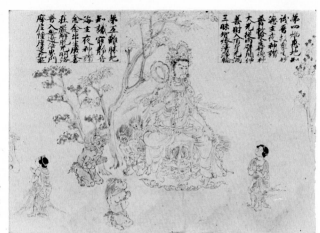

130. Section from the Kegon Gojugo-sho *(Zenzai Doji's Pilgrimage to the Fifty-five Saints) picture scroll. Colors on paper; height, 29.7 cm. Thirteenth century. Todai-ji, Nara.*

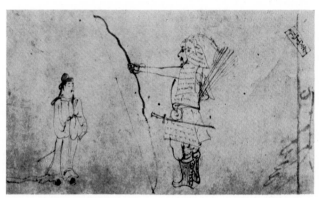

131. Section from the Shogun-zuka Emaki *(Tomb of the Shogun Picture Scroll), copy. Ink on paper; height, 30.9 cm. Thirteenth century. Kozan-ji, Kyoto.*

132. Section from the Joan Go-sechi Emaki *(Picture Scroll of the November Festival at the Imperial Palace in the Joan Era). Colors on paper. A copy, based on an original by Tokiwa Mitsunaga dating from 1171, the first year of Joan. Tokyo National Museum.*

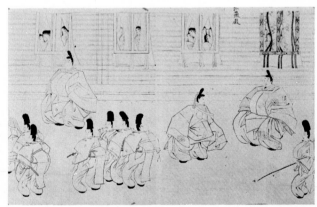

133. Section from the Tadamine-shu *division of the* Sanjuroku-nin Shu *(Thirty-six Poets' Anthology). Ink on decorated paper; height, 20.1 cm.; width, 31.8 cm. First half of twelfth century. Nishi Hongan-ji, Kyoto.*

in it the possibility of development in two contrasting directions—the pure aristocratic art exemplified by the *Genji* scroll on the one hand, and on the other hand, the type of art represented by the *Shigi-san* scroll. The emergence of the *Shigi-san*, breaking out of the circle of the nobility and into the life of the common people, clearly shows the new historical drift during the *insei* administration. With the nobility a dying political force, the samurai and small landowners of the provinces launched a new movement that could not be halted. And the new culture was bound to reflect this social situation.

Indicative of the sociopolitical watershed seen by the times are the many hagiographies that note a new kind of person attaining Buddhahood in Amida's paradise. The *Shui Ojoden* (On Rebirth in Paradise) and *Goshui Ojoden* (More on Buddhahood) by Miyoshi Tameyasu, or the *Shinshu Ojoden* (On Rebirth in Paradise Revised) by Fujiwara Munesada, are noteworthy compilations by bureaucrats belonging to the lower-class nobility. In leafing through them one comes across a certain Shimomichi Shigenari, "a man of rude culture, dwelling in Sakyo"; and Ki no Yoshizumi, "a peasant in the village, of truly mean estate"; and even one Sashinuki no Kimi, whose "business is to thieve and murder"—all persons of the lower classes, now counted among the blessed. The rank and file surely wished no part of the high-class Buddhism of traditional or esoteric sects preached by the caste of high priests. These references reflect the roots that the new sects were starting to sink in society's lower echelons. In the entertainment world also,

134. *Underpainting for the* Menashi-kyo *("Featureless Faces" Sutra). Ink on paper; height, 26 cm. Before 1175. Kyoto National Museum.*

at the end of the eleventh century, *dengaku* (music and dancing performed by peasants at rice-planting time) was catching on with the upper classes. Folk songs, especially romantic ones, and sometimes satirical songs called *imayo* (literally, "contemporary style," as opposed to the ancient style; the free, poetical song type popular in late Heian times) were sung by aristocrats. And around 1179, the retired emperor Goshirakawa (1127–92) himself put together the *Ryojin Hisho,* an anthology of religious and folk songs (mostly *imayo*). Thus the penetration of popular elements into various branches of culture became an important characteristic of the period of *insei* administration. That nobility could create a scroll like *Genji,* yet enjoy the *Shigi-san* scroll, is not at all strange.

Story of the Courtier Ban Dainagon (Figs. 10, 33, 43, 67, 68, 116), treating of Ban Dainagon's political intrigues, does not show the movielike pictorial continuity of the *Shigi-san* on the whole; however, its scene of the burning of the Otemmon Palace has as much, if not more, live action as the *Shigi-san.* The portrayal of the crowd is wonderful, and the common people are squarely in the limelight.

Scholarly opinion is divided over how to interpret the *Choju Jimbutsu Giga* (Figs. 34, 35, 65, 66). These four famous picture scrolls of Kozan-ji are actually composed of one scroll with animal sketches and one scroll each devoted to cartoons of animals, people and animals, and people only. Date and artist are not necessarily the same for all, but there is some evidence that the best—the scroll of bird and animal cartoons—may be attributed to the pioneer of new Buddhist painting, Toba Sojo.

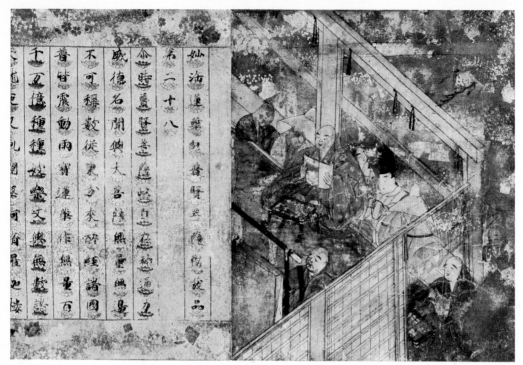

135. *Frontispiece of the* Ichiji Rendai-kyo *(Lotus-decorated Lotus Sutra). Colors on paper, height, 21.2 cm. Twelfth century. Yamato Bunkakan, Nara.*

These scrolls developed in pure form the *giga* characteristic that was later to become one constituent of the *Shigi-san* style. There is no writing; the pictures carry the aesthetic thrust by themselves.

Minister Kibi's Visit to China (Fig. 42) and *Kokawadera* (Fig. 81) are scrolls artistically slightly inferior to the three mentioned above, but should be considered as painting of the same category.

I have been commenting so far only on original works, but among works that exist only in the form of copies, there is one with a truly dynamic depiction of ordinary people in day-to-day life: the *Nenju Gyoji Emaki* (Picture Scroll of Annual Rites and Ceremonies; Figs. 82, 115). The twelfth-century original, commissioned by Goshirakawa, was painted by Tokiwa Mitsunaga. I think of it as a panorama of Japanese society in late Heian. People from every class—nobles, city folk, peasants—are shown. Of the same type are *Shogun-zuka* (Tomb of

the Shogun; Fig. 131) and *Hikohohodemi no Mikoto*, with its fairy tales about the hero of the same name. These latter two appear to have had originals dating from about the same time.

HIGI-GA AND ROKUDO-E Despite their importance, *higi-ga* (literally, "pictures of secret pleasures") have certainly been ignored in Japanese art history until now. Without them it would be impossible to understand ukiyo-e, and although this is not true for Yamato painting, they may still not be overlooked in any scholarly study.

For this reason I have presumed to break precedent and include glimpses from the famed but rarely seen *Kanjo no Maki* (Initiation Scroll; Fig. 140) and *Chigo no Soshi* (Acolytes' Scroll; Fig. 141). The *Kanjo no Maki* is also known as *Koshibagaki Zoshi*, or Brushwood Fence Scroll. It is not certain

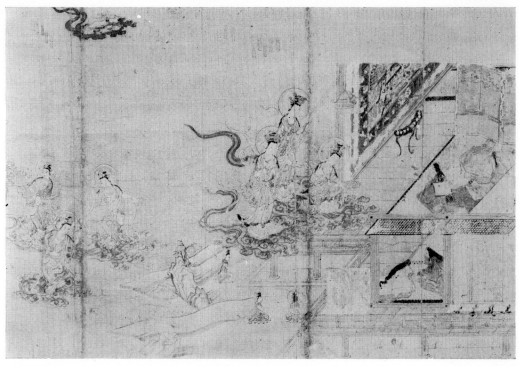

136. Section from the Taima Mandara Engi *(Legends of the Taima Mandala) picture scroll. Colors on paper; height, 48.8 cm. Thirteenth century. Komyo-ji, Kanagawa Prefecture.*

whether the original still exists. According to the late Professor Fukui this work was presented by Kenshummon-in, consort of Goshirakawa, to her niece, Taira Tokuko (1157–1213), on the occasion of the latter's marriage to Emperor Takakura (r. 1168–80). *Chigo no Soshi* depicts sodomy and dates from 1321.

Let us now turn to *rokudo-e*. As the historic wave of change broke over the ruling class during the *insei* administration and shattered its small, sheltered world, wider horizons fell open to view; in fact, more than a broader outlook was thrust upon aristocrats. Accustomed to seek beauty and beauty only, they now could no longer avoid being confronted with the ugly side of life and people.

When the lovely *Genji* scroll or the Nishi Honganji *Thirty-six Poets' Anthology* are set alongside the scroll group made up of the *Scroll of Hell* (Figs. 44, 78, 79, 137), the *Scroll of Hungry Ghosts* (Figs. 9, 80),

or the *Scroll of Diseases and Deformities* (Figs. 45, 76, 77), there is a startling contrast of the beautiful and repulsive almost too horrid to behold. That the appalling and the enthralling could be painted in such quick succession is some indication of the swift-changing times so traumatically affecting the nobility.

Scholars cannot reach a consensus as to the nature of the three scrolls in the foregoing group. In particular, some scholars have strong doubts as to whether the *Scroll of Diseases and Deformities* is on the same theme as the other two. However, considering that the titles *Scroll of Hell* and *Scroll of Hungry Ghosts* are not to be seen until the Edo period, whereas references to scrolls called *rokudo-e* occur in records from the early middle ages on, I shall follow Professor Fukui's opinion and treat all three scrolls as belonging to the *rokudo-e* scroll category.

Although Professor Fukui interpreted the *rokudo-e*

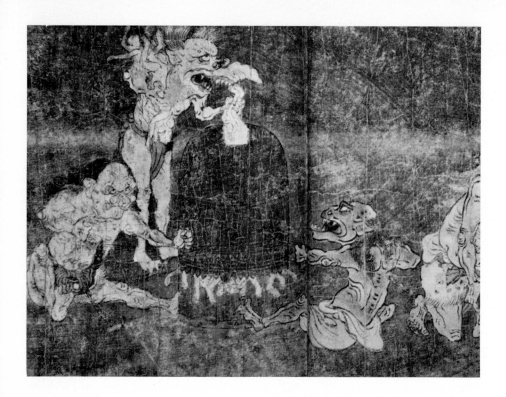

as illustrations for the Lotus Sutra, I regard them as representations of the six regions of suffering as explained in the *Ojoyoshu* (The Essentials of Salvation), the religious vade mecum written by the priest Genshin in 984. This book describes in detail the foulness of the six regions of the Impure Land, i.e., hell, hungry ghosts, animals, warring demons, men, and heaven, and preaches the importance of abhorrence of this world and of the yearning for the Pure Land. The Amidism of Genshin was nonsectarian, and the universality of the doctrine in *The Essentials of Salvation* is one reason why its themes were adopted in a number of literary works, such as the *Homotsushu,* a collection of Buddhist legends compiled by Taira Yasuyori; the *Heike Monogatari;* and also in the great war romance of mid-Kamakura, the *Gempei Seisuiki,* which relates the rise and fall of the Taira and Minamoto clans. An interesting sample of catechetical art based on

Genshin's *Ojoyoshu* is the *rokudo-e* silk painting for a hanging scroll (Fig. 127) at Raigo-ji temple. It belongs to the *jikkai-zu* (ten realms of living beings) type. *Rokudo-e* picture scrolls should be placed in this greater context.

Of the six regions just mentioned, hell, hungry devils, demons, and heaven pertain to the realm of the unseen, while beasts belong to the visible but nonhuman world. Each is a terrible or painful phase of the present vale of tears. In the *Heike Monogatari* mention is made of Kenreimon-in, the former Taira Tokuko, and her sad share of sufferings of the six worlds. Not only the *Scroll of Diseases and Deformities* with its depiction of one phase of human suffering, but also the difficult stages of growing old and dying as found in the *Scroll of Hell* and *Scroll of Hungry Ghosts* are important to an understanding of *rokudo-e* picture scrolls.

Rokudo-e is certainly something extraordinary in

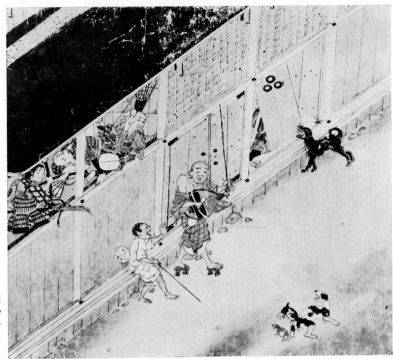

137. *Section from the* Jigoku Zoshi *(Scroll of Hell), original. Colors on paper; height, 26.7 cm. Late twelfth century. Nara National Museum.*

138. *Section from the* Boki Emaki *(Biography of Priest Kakunyo Picture Scroll), by Fujiwara Hisanobu. Colors on paper; height, 32.1 cm. Dated 1351. Nishi Hongan-ji, Kyoto.*

the long history of Japanese arts that are traditionally so elegant, and it is a remarkably successful painting form for such rare subject matter. In 1958, the paintings traveled to Europe for exhibition, and they are reported to have also made a strong impression on the Western world.

THE DEVELOPMENT OF PORTRAITURE Since portraiture always held an important place in Chinese art, it was of course also vigorously taken up in Japan during the time *kara-e* were produced. Moreover, there was the custom of venerating paintings of founders of sects in religious settings. In sculpture, too, early examples existed, such as the figure of the T'ang-China priest Ganjin (688–763) at Toshodai-ji. Paralleling this was portraiture of the seven patriarchs of the Shingon sect; of Jion Daishi, a Chinese priest of the seventh century; or of eminent priests of the Tendai sect. These portraits were sometimes of just one person and sometimes of a number of prominent ones. Prince Shotoku was a layman, but, as the founder of many temples, his portrait (Fig. 107) also belongs to the religious-founders category, I believe. Portrait techniques were certainly not lacking, but the Heian-period aristocracy was not inclined to idolize or worship secular personages; consequently, the *yamato-e* of that period in particular never ventured into realistic treatment of the person.

In the late Heian period, a custom imitative of Confucian students who venerated the portrait of Confucius sprang up among poets. Portraits of the supposed originator of *waka* poetry, Kakinomoto no Hitomaro, began to be honored ceremonially (Fig. 55). These paintings were, of course, mostly works of the imagination and not portraiture in the true sense. But with time, the demand grew for

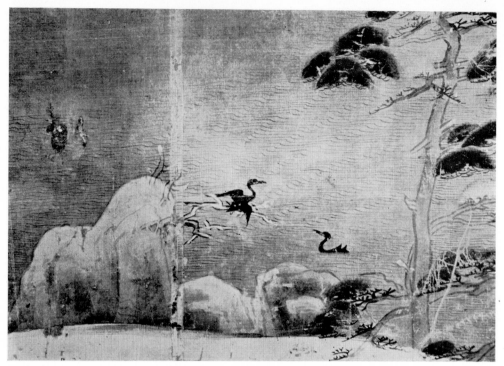

139. Detail from the Zemmui Dainichi-kyo Kantoku Zu *(Subhakarasimha's Vairocana Sutra Inspiration), by Fujiwara Munehiro. This is the only Heian-period painting where the artist's name is known. Panel painting; colors on silk; dimensions of entire painting: height, 177.8 cm.; width, 141.8 cm. About mid-twelfth century. Fujita Art Museum, Osaka.*

pictures of great poets and resulted in the Kamakura-period *Thirty-six Poetic Geniuses* scroll (Figs. 87, 100). In the end, however, one hesitates to assign it the name of portrait painting.

The Heian-period nobility evidently found realism too much to bear and so they adhered to formalistic expression even in their own portrayal, as seen in the bare suggestion of features (the eyes and nose) with the *hikime-kagihana* approach. (This disavowal of the warts in favor of the winsome reappeared in later painting: ukiyo-e artists gained a great following by pointedly setting aside the personal idiosyncrasies of the prostitutes and actors who were their models, opting instead for a well-turned formalism. Toshusai Sharaku, an exception, strove for realism in his paintings of performers, only to be rewarded with the loss of his popularity. Crestfallen, he put away his palette entirely.)

The panels in the Saishoko-in temple of Kyoto, executed in 1173 by the court artist Tokiwa Mitsunaga, showed scenes of the emperor's various visits to great places such as the Hie Shrine or Mount Koya. It seems that Minister Fujiwara Takanobu (1142–1205), who also painted like so many noblemen of his time, was commissioned especially to paint just the faces of the people in the panels, but only those of ministerial rank or below. The courtier Fujiwara Kanezane is reported to have been gleeful about his absence on the occasion, and hence from the painting—a sure clue to the traditional aristocratic dislike for personal close-ups in art. Not everyone was like Kanezane, however, and the inclination evident here—having the features especially painted by an expert in the field—was the harbinger of the new realism.

As the episode just mentioned suggests, a fresh

realism was on the way. The collapse of the court in Kyoto was certain, and from the scrambled social order emerged new political faces and feudal militarists who left their personal stamp everywhere. People began to want portraits. The talents of an artist like Takanobu had been sought for the faces only because he was a master of realistic portraiture. That is how the *nise-e* tradition began, with Takanobu as its founder. His son Nobuzane (1176?–1266?) was no less a master. Takanobu is reputed for his *Portrait of Yoritomo* (Fig. 14) and Nobuzane for *Portrait of Retired Emperor Gotoba* (Fig. 93). Neither attribution is confirmed, but then why should we doubt them? The works were obviously painted from sittings, or at the least from remembered encounters between painter and subject. (A corner of the chronicle *Biography of Saint Honen* shows the founder himself sitting for a portrait; Fig. 144.)

Takanobu's descendant, the famous but enigmatic Goshin (active between 1334 and 1349) leaves a portrait of the retired emperor Hanazono (r. 1308–18; Fig. 104). Also highly esteemed is the portrait of Saint Shinran, known as Kagami no Mi-ei (Fig. 105), a product of Takanobu's direct line by the son of Nobuzane, Sen Amida Butsu. The work is obviously in the true *nise-e* tradition. Another painting of Shinran, known as Anjo no Mi-ei, might also be by the same artist.

In the picture-scroll medium, the *nise-e* vogue led to paintings I mentioned earlier: *Portraits of Emperors and Ministers* (Fig. 86), *The Imperial Guard Cavalry* (Fig. 92), and *Portraits of the Emperor and Courtiers Gathered in the Imperial Palace* (Fig. 94). In animal depiction, *nise-e* gave birth to unique scrollwork such as the *Fine Ox* (Fig. 85).

This, in effect, was how portraiture of lay persons, who had not figured at all as painting subjects in the ancient period, took root. The form saw great popularity during Muromachi times (1336–1568), when many portraits were done of shogun and daimyo by the best artists of the day. Those like the one of Masuda Kanetaka by the famous ink-monochrome master Sesshu Toyo (1420–1506) exemplify the Yamato style in the portrait genre. The trend continued on into the Edo period with

portraits of great generals, such as Oda Nobunaga or Toyotomi Hideyoshi.

REALISTIC LANDSCAPES

The intransigent realism, depicting subject matter as it was, encouraged realistic portraiture and, in the process, set up sympathetic vibrations elsewhere. A realistic landscape approach appeared that can in no way be compared to the poetic places and treatment of Heian *meisho-e,* with its exotic, unrealistic array of subjects.

In 1207, when work on the *meisho-e* panels at Saisho Shitenno-in temple was under way, the painter Kaneyasu made the short jaunt by horse to actually see Akashi and scenic Suma on the strait, so that—to go by the account—posterity might not be led astray by his brushmanship.

Yamato painting had certainly come a long way since the days of Noin Hoshi and his song of Shirakawanoseki, so airily composed from the comfortable distance of Kyoto.

No chance of history created the *Biography of Saint Ippen* (Figs. 53, 108, 109) kind of scroll, with its realistic, traveloguelike paintings of famous places from all over Japan. It would be no misnomer to call it the picture scroll of Japanese landscape painting. The *nise-e* spirit of portraiture had found a home in scenery painting, too.

The *yamato-e* ideal of depicting nature and man inseparably united was not altogether forgotten even in the middle ages. Consequently pure landscape paintings, having only landscapes for their themes, did not appear in Yamato painting even in medieval times. Furthermore, the fact that the main form of *yamato-e* was the picture scroll, which illustrated tale literature, made the appearance of an independent landscape genre even less likely. However, there were paintings that could be called *yamato-e* landscapes. These are the devotional mandala paintings of Shinto shrines, which frequently have a decidedly landscapelike flavor, having a panoramic view of the shrine in its setting of natural scenery.

Truly unique of its kind is the hanging scroll *Nachi Falls* (Fig. 102), probably dating from late Kamakura times. Painted as a symbol of the god

140. Detail from the Kanjo no Maki *(Initiation Scroll; also known as* Koshibagaki Zoshi, *or Brushwood Fence Scroll)*, copy. Colors on paper. Original dating from about 1171.

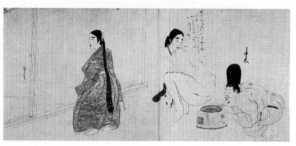

141. Section from the Chigo no Soshi *(Acolytes' Scroll)*. Colors on paper; height, 30.6 cm. Dated 1321. Sambo-in, Kyoto.

Hiryu Gongen, it basically belongs to the religious category in the manner of Buddhist painting. As depiction of a great falls with no one in sight, this painting points to where *yamato-e* might have gone, had it been occupied with landscapes as such.

PICTURE SCROLLS OF THE MIDDLE AGES The Kamakura period, taken from the viewpoint of political history, is the time of the Kamakura military government takeover, the *insei* administration of the cloistered emperors, and the manorial system that still hung on. Consequently, the culture, too, reflected a certain duality. On the one hand, the aristocracy strove to keep traditions alive; on the other, the military class, backed by the masses, was just as determined to carve out a cultural niche of its own.

In the ancient literary tradition were the *waka* of the *Shin Kokin* imperial poetry anthology and the court-*monogatari* favorites: *Hermit's Robe; Iwashimizu Monogatari* (Prayers For Love at Hachiman);

Koiji Yukashiki Daisho (The General's Ideal Woman); or *Towazugatari* (A Concubine's Diary). Paintings in the *emakimono* form were the *Tale of Nezame* (Fig. 47), the *Diary of Lady Murasaki* (Fig. 46), the *Tale of Splendor* (Fig. 89), and the *Tale of Sumiyoshi* (Fig. 88). These showed the emotion and color of the *Genji* picture scroll. Striving for the same effect, without color, there were *The Pillow Book* (Fig. 90) and *Love Letters of Lord Takafusa*. The thoroughly decorative approach of *Tales of Ise* (Fig. 49) makes it seem the predecessor of the great decorative styles of the Edo artists Sotatsu and Korin. The last three scrolls especially, while inheriting the Heian-period style of painting, opened up completely new fields.

The cluster of scrolls dealing with miracles— *Kitano Tenjin Engi* (Figs. 50, 125), *Matsuzaki Tenjin Engi* (Figs. 101, 119), *Kasuga Gongen Kenki* (Figs. 28, 57, 110), and *Ishiyama-dera Engi* (Fig. 51)—exhibit rich colors and scale that aptly impress the beholder. They are a brilliant series of paintings.

142. A rough draft of the Kiyomizu-dera Kana Engi (Legends of Kiyomizu-dera in Syllabic Script) picture scroll. Ink on paper. Early thirteenth century. Kongo-ji, Osaka.

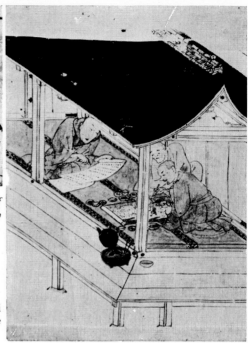

143. A scroll in the making, from the Boki Emaki (Life of Priest Kakunyo Picture Scroll).

Stylistically the group has the exquisite color of the *Genji* and busy line of the *Shigi-san*, while the content is managing to deal with the entire spectrum of *yamato-e*: the lives of the aristocracy, the samurai, and the common people; the weird elements from *rokudo-e*; and even the scenic settings of temple or shrine.

Kitano Tenjin centers on the life of Sugawara Michizane, a colorful ninth-century politician and man of letters. Following his death, Michizane was deified at Kitano and came to be regarded as the patron god of learning. This scroll is of singular quality among the many scrolls of the same title. The two remaining scrolls of the Koan version are also famous. *Kasuga Gongen* is exceptional for the inscription it carries giving details of its origins. Dated 1309, the scroll was produced by the art-bureau director of the court, Takashina Takakane. The narrative is by the former chief councilor to the emperor, Takatsukasa, and others. The fifty or more stories in twenty scrolls offer an extremely interesting and broad range of subjects. *Ishiyama-dera*, closely resembling the *Kasuga* scroll in painting style, is also thought to be from the brush of Takashina Takakane. There are seven scrolls in all, including two added in later years.

The Kitano and Kasuga shrines and the Ishiyama temple—founded in ancient times—each have a history closely interwoven with aristocratic culture, and the scrolls depicting their legends evoke this fact. That they included snatches of the lives of the common people, however, was closely related to the turmoil of the changing times. But when it comes to scrolls whose themes were the founders of new Buddhist sects that arose during the Kamakura period, we find that they concern themselves with the lives of the lower classes more directly.

The pictorial biographies of the priests Honen (Figs. 54, 144; a total of forty-eight scrolls), Shinran, and Kakunyo (1270–1351) may not be overwhelming art; however, the *Biography of Saint Ippen*

(Fig. 53) is a meticulously handled, true-to-life masterpiece, telling of missionary journeys, samurai, and common people, replete with scenery from the length and breadth of Japan. Yamato painting in Heian times never had anything comparable.

The founder-type biographical scroll was not the aesthetic domain of the new sects alone, however. There is the scroll of the Kegon sect, the *Kegon Engi* (strictly speaking, the scroll is named *Gisho Daishi Gangyo Daishi Emaki*, or Scroll of the Founder Ui-Sang and the Great Missionary Wonhyo; Fig. 52). Produced in early Kamakura times at the Kozan-ji temple in Kyoto, this scroll has the irrepressible line of the *Shigi-san* or *Choju Giga* and adds a unique touch of pale colors. *Travels of Genjo Sanzo to India* (attributed to Takashina Takakane; Fig. 56)—stylistically similar to the *Kasuga Gongen* (Fig. 57)—and *The Eastern Journeys of Priest Ganjin* (Fig. 91), with the latter strongly influenced by Sung painting, are two scrolls attesting to a *kara-e* revival of sorts. The landscapes and people are entirely alien. *Eastern Journeys*, together with the *Mongol Invasion* scroll I am about to discuss, were both painted in the Kanto region (the area centering around Tokyo). This means that Yamato-style painting had become a cultural phenomenon throughout Japan.

The beginning of the Kamakura period saw a flurry of military tales: *The Tale of the Hogen Rebellion, The Tale of the Heiji Rebellion,* and *Tales of the Heike,* for example. The first two were soon adapted into the scroll medium. As the picture scroll *Three Years of War* had already set a precedent in the Heian period, the appearance of the two scrolls did not cause a great stir. At present, *The Tale of the Heiji Rebellion* picture scroll (Figs. 48, 58, 113), tracing a grim picture of bloody clashes, is our earliest extant painting of this kind, however, and although *The Tale of the Hogen Rebellion* scroll does not survive, in the works of Sotatsu and other later painters, the influence of the original is seen.

Mongol Invasion (dated 1293; Fig. 59) records the life of Takezaki Suenaga, a warrior from Kyushu who fought against the Mongols. It is made up of two scrolls, the first showing the 1274 campaign and Suenaga's subsequent trip to the Kanto region,

and the second scroll depicting the 1281 campaign. Suenaga donated them to his local shrine. The fact that even a provincial warrior could commission a painting in the Yamato style is palpable evidence of the march of time. Here is depiction of soldiers giving their lives in battle, a cross section nowhere to be found in the art of the easy-living nobility of the past. The handling of the groups of people in the early fourteenth-century *Heiji* scroll is also remarkable, yet the peak of technical development had already been passed. Yamato painting was declining along with aristocratic culture—the warriors had better turn elsewhere.

Not to be overlooked among painting of the period are the *Biography of Priest Saigyo* (Fig. 60) and the *Poetry Contest on Newly Selected Scenic Spots in Ise* (Fig. 61) picture scrolls. Introducing a host of novel elements not seen in the court tales, these evoked a lyrical approach to landscape and gave entirely new meaning to scroll art of the *Genji* tradition. *Obusuma Saburo Emaki* (Fig. 112), thought to be the work of the same artist as the *Poetry Contest*, is of almost fairy-tale character. It is very interesting for the coverage of the life of the rural samurai that we do not get from the *Mongol Invasion* or *Heiji* scrolls.

Story of a Painter (Fig. 111), the tale of a poverty-stricken painter whose overnight rise to rank ends in personal ruin, is a humorously depicted insight into the life of an artist of the middle ages.

The Muromachi period (1336–1568), too, saw many picture scrolls produced. However, by then Yamato painting had run its course. *Legends of the Yuzu Sect* (Fig. 62) records the life of the founder, Ryoshin (1072–1132), and the rise of the Yuzu Nembutsu sect (one of the sects that practiced chanting the Buddha's name). Many copies are extant and it achieved widespread circulation in the form of woodblock reproductions. Figure 62 shows a section of the original scroll dating from 1414. Although the scroll tradition was already dying when it was painted, the portrayal of the people is nevertheless thoroughly lifelike and deserves mention. *Legends of Seiko-ji* (Fig. 118) is the work of Tosa Mitsunobu (d. 1521), the last painter in the Yamato line. And I should also mention

144. Nise-e *portrait sitting, from the* Honen Shonin Gyojo *(Biography of Saint Honen) picture scroll.*

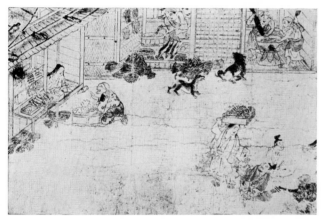

145. Section from the Naomoto Moshibumi Emaki *(Petition of Naomoto Picture Scroll). Colors on paper; height, 30.6 cm. Fourteenth century. Kamei Collection, Tokyo.*

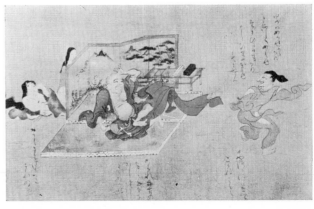

146. Section from the Fukutomi Zoshi *(Story of Fukutomi) picture scroll. Colors on paper; height, 31.2 cm. Fifteenth century. Shumpo-in, Kyoto.*

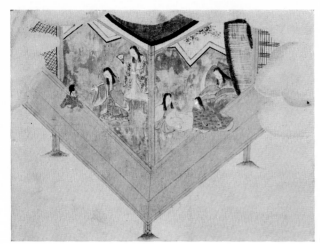

147. An illustration from the Ko-otoko Zoshi *(Tale of a Tiny Man)*, a Nara ehon. *Colors on paper; height, 33.7 cm. Sixteenth century. Tenri University Library, Nara Prefecture.*

148. Section from the Nampuku Zukan *(Picture Scroll of Seven Smiles or Frowns of Fortune)*, by Maruyama Okyo. Colors on paper; height, 32.3 cm. Dated 1768. Emman-in, Shiga Prefecture.

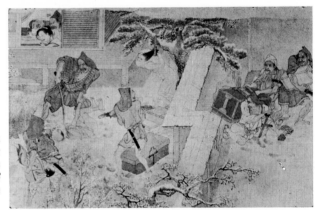

149. Two facing pages from the Shiranui Monogatari *(The Spider Web Tale)*, a kusa-zoshi *(illustrated storybook)*. Height, 17.8 cm. Dated 1854.

Story of Fukutomi (Fig. 146) as typical of the *otogi-zoshi* (fairy-tale) form.

Let me interpose here this brief description on how an *emakimono*—the "documentary of the middle ages"—was actually made. An interesting glimpse of the process is provided by a scroll dating from those times (Fig. 143). But whether this was actually how scrolls were made is still a question. One fascinating scroll draft survives, however, providing us with a running commentary on the actual process (Fig. 142). It was discovered in the Kongo-ji temple at Kawara near Osaka. There are rough sketches inserted here and there in the text, with instructions to the artist as to what kind of illustration is to be painted there. The same method was used by Edo-period writers of fiction. Although all picture scrolls may not have been done in exactly this manner, it is intriguing all the same.

THE INHERITORS OF THE YAMATO-E TRADITION

By the mid-Muromachi period, scroll painting in the Yamato style had disappeared, but the tradition it had begun lived on in Japanese painting thereafter, either in spirit or in other forms.

First of all, painting in scroll format (i.e., *emakimono*) was a form long afterward loved apart from *yamato-e*. The Edo period (1603–1868), with the renaissance of Yamato painting under the aegis of the Sumiyoshi school (an offshoot of the Tosa school), produced cityscape painting like the *Rakuchu Rakugai* (Scenes In and Around Kyoto) scroll by Sumiyoshi Gukei (1631–1705). The aim was definitely to prolong the Yamato tradition. And in ink-monochrome painting, a form that could not be more different from the Yamato style, Sesshu explored the possibilities of the medium to their limits with his masterly *Long Landscape Scroll* (Sansui Chokan). The various schools of the Edo period had mostly taken their lessons in *kanga* (painting by Japanese artists in the Chinese styles of the Sung, Yuan, and Ming periods), which accounted for the great difference between Edo painting and the ancient *yamato-e*. But in ukiyo-e, which evinced such close affinities with Yamato

painting, there were Hishikawa Moronobu's (1618–94) genre scrolls; Maruyama Okyo's *Nampuku Zukan* (Seven Smiles or Frowns of Fortune Scroll; Fig. 148); or even in our present-day *nihon-ga*, Taikan Yokoyama's (1868–1958) picture scroll, the *Seisei Ruten* (The Cycle of Life). All these attest to the deep roots of the scroll tradition.

The styles are entirely different from that of the original *yamato-e*, but the horizontal scroll form, wherein painting shows gradually unveiled temporal progression, has been undeniably the same ever since the days of the *Shigi-san*.

The *yamato-e* tradition not only continued in the scroll medium, but found another form in the combination of literature and painting. That is to say, the characteristics of *yamato-e* of the *kami-e* type (small paintings combined with text, in book or scroll form) were during and after the middle ages inherited in the form of picture books, or *ehon*.

Painting in the Yamato style underwent changes during the Muromachi period, evolving into fairy-tale illustration, and finally into the so-called *Nara ehon* (gorgeously illustrated storybooks; Fig. 147). But in the Edo period, literature of the townsmen and ukiyo-e attracted one another, and then developed as an artistic duo.

At the dawn of the modern period, during the roughly fifty years between 1688 and 1735, the epicurean prose of the *ukiyo-zoshi* for merchant tastes arose, but art was still only being courted by literature. By late Edo, in the first half of the nineteenth century, the newlyweds had become so inseparable that prose without pictures would have been unthinkable. Exemplars of this bond were the witty *kusa-zoshi*, which carried an illustration on every page and where the prose was often only explanation for the pictures (Fig. 149). Or there was the literary form called *ninjo-bon*, illustrated stories of the love affairs of the citizens of Edo. If we read the text alone of one of these works, we could not recognize any artistic quality in it.

Literature since the Meiji era (1868–1912) has rejected the illustrated popular fiction of the Edo period and has strived to emulate the spirit of modern Western literature. Even so, because of the longstanding custom of reading fiction in con-

150. Frontispiece of the Chuson-ji Kyo *(Chu-son-ji Sutra). Gold and silver on dark-blue paper; height, 25.8 cm. First half of twelfth century. Chuson-ji, Iwate Prefecture.*

junction with them, illustrations are indispensable for the majority of popular fiction. Installments of novels in newspapers and the like now invariably carry an illustration—a custom that is unconscious witness to the longstanding Yamato picture book tradition.

More important than these other forms is the matter of how the spirit of *yamato-e* lived on in the various schools of the ensuing centuries.

The importation of Chinese painting in the middle ages led first to the fashion for ink mono-chromes. This represented a new Chinese style of painting, *kanga,* which replaced the enfeebled *yamato-e* as the main form of Japanese painting. Presently, the *kanga* style and that of the Tosa school, which was the heir of the Yamato tradition, combined, resulting in the Kano school. Considering the lineage of this school, it is only natural that the characteristics of classical *yamato-e*

should reappear in some form or other as part of the style of the Kano school.

With the thrust from the Kano school, many other schools of painting appeared in the Edo period—the Sotatsu-Korin, Maruyama, and Shijo schools and the ukiyo-e genre, to mention but a few—all of which deferred to the Yamato tradition in one way or another. It was only after having first mastered the *Genji,* the *Hogen* or *Heiji,* the *Saigyo,* or a plethora of ancient and medieval picture scrolls that the incomparable Sotatsu ef-fected his own original artistic synthesis in a new decorative style. I think his works were far truer to, more an authentic revival and prolongation of, Yamato painting than the feeble attempts of the Tosa or Sumiyoshi schools, which ostensibly made a thing of painting in this style only, but perhaps clung to the name more than to its spirit.

Ukiyo-e may seem insignificant as compared to

151. Dokan'yama Mushi-kiki no Zu *(Listening to Insects on Dokan Hill)*, by Ando Hiroshige. Color print. Mid-nineteenth century.

152. Satsuki Matsu Hamamura *(Beach Hamlet in Late Spring)* folding screen, by Eikyu Matsuoka. Colors on silk; height, 110.6 cm.; width, 207.9 cm. Dated 1928. Matsuoka Collection, Tokyo.

the towering art of Sotatsu. Nevertheless, next to the great decorator's retreat into the ancient past, the preoccupation of ukiyo-e with the "now" and its ringing affirmation of the actual in Japanese life bring it ultimately much closer to the *yamato-e* subject-matter approach. The central aim of the Yamato painting—man as a part of nature, nature as a part of man and his life—is found in ukiyo-e, and is most emphatically revived in the late-Edo landscapes of Ando Hiroshige (Fig. 151) and his followers. Some ukiyo-e artists even called themselves *yamato-e* painters, and consciously strove to carry forward the tradition. There is no doubt that ukiyo-e definitely had hold of the spirit of *yamato-e*.

After the Meiji Restoration in 1868, even more effort was put into "rethinking" Japanese classical art, and ideas of art history gained in breadth. The study of the styles of the various historical schools gained momentum—there were even artists who

attempted to absorb the style of the Horyu-ji murals. It would be surprising indeed, therefore, if nobody had studied *yamato-e*, which occupies such an important position in the history of Japanese painting. And in fact there is now a declared *yamato-e* movement that aims to prolong the original tradition and that figures importantly in the Japanese art world. I am no authority on modern art, but, unless I am mistaken, the landscape of, say, Eikyu Matsuoka (1881–1938; Fig. 152) and his following is much more the modern approximation of Yamato landscape painting than historical painting attempts to resurrect it with elements drawn from picture scrolls.

Although the forms of the spirit are inherited from painting that exists no more, it is this living tradition, under other names and in other forms, which is the most eloquent testimony to the immense significance of *yamato-e* over the centuries.

APPENDIX

Extant Picture Scrolls

THE SAMPLING OF THE most representative picture scrolls in the following list is based on the classification worked out by two scholars: the late Rikichiro Fukui and Hideo Okudaira. The reader is reminded that this is purely provisional, as there is disagreement among scholars about *yamato-e* categorization.

The letters N, H, K, and M signify the Nara (646–794), Heian (794–1185), Kamakura (1185–1336), and Muromachi (1336–1568) periods, respectively, as the general time of production, and SSN indicates that there are many others scrolls called by the same name. The scrolls are in color except where otherwise indicated.

I. SECULAR THEMES

a) Court Tales and Diaries (*ocho-fu monogatari; nikki*)

Genji Monogatari Emaki (The Tale of Genji); H

Nezame Monogatari Emaki (Tale of Nezame); K

Murasaki Shikibu Nikki Emaki (Diary of Lady Murasaki); K

Makura no Soshi Emaki (The Pillow Book); monochrome; K

Eiga Monogatari Emaki (Tale of Splendor); K

Sagoromo Monogatari Emaki (The Loves of Courtier Sagoromo); K

Sumiyoshi Monogatari Emaki (Tale of Sumi-yoshi); K

Itsuna Monogatari Emaki (Nameless Tale); K

Nayotake Monogatari Emaki (Tale of a Young Bamboo); K

Takafusa-kyo Tsuyakotoba Emaki (Love Letters of Lord Takafusa); monochrome; K

Ise Monogatari Emaki (Tales of Ise); K

b) Narrative Accounts (*setsuwa monogatari*)

Shigi-san Engi Emaki (Legends of Shigi-san Temple); H

Ban Dainagon Emaki (Story of the Courtier Ban Dainagon); H

Kibi Daijin Nitto Emaki (Minister Kibi's Visit to China); H

Shogun-zuka Emaki (Tomb of the Shogun); copy; monochrome; H

Hikohohodemi no Mikoto Emaki (Picture Scroll of Prince Hikohohodemi); copy; H

Kanjo no Maki (Initiation Scroll; also known as *Koshibagaki Zoshi,* or Brushwood Fence Scroll); copy; H

Saigyo Monogatari Emaki (Biography of Priest Saigyo); K

Saigyo Hoshi Gyojo Emaki (Picture Scroll of Saigyo's Deeds); Sotatsu version; copy; K; SSN

Chigo no Soshi (Acolytes' Scroll); K

Haseo-kyo Zoshi (Tale of Lord Haseo); K

Naomoto Moshibumi Emaki (Petition of Nao-moto); K

Eshi no Soshi (Story of a Painter); K

Obusuma Saburo Emaki (Story of the Samurai Obusuma Saburo); K

Zegaibo Emaki (Epic of Zegaibo, the Chinese Goblin); K

c) Military Tales (*gunki monogatari*)

Hogen Monogatari Emaki (The Tale of the Hogen Rebellion); copy; K

Heiji Monogatari Emaki (The Tale of the Heiji Rebellion); K

Moko Shurai Emaki (Mongol Invasion); K

Zen Kunen Kassen Emaki (Nine Years of War); M

Gosannen Kassen Emaki (Gosannen Battle); M

Yuki Kassen Emaki (Yuki Battle); M

Heike Monogatari Emaki (Tales of the Heike); monochrome; M

d) *Waka* Scrolls

Sanjurokkasen Emaki (The Thirty-six Poetic Geniuses); K; SSN

Ise Shin Meisho Uta-awase Emaki (Poetry Contest of Newly Selected Scenic Spots in Ise); K

Tohoku-in Shokunin Uta-awase Emaki (Tohoku-in Poetry Contest Among Members of Various Professions); K

Jidai Fudo Uta-awase Emaki (Portraits of Poets of Different Periods and Their Poems); K

e) Records of Old Customs (*kojitsu kiroku*)

Nenju Gyoji Emaki (Annual Rites and Ceremonies); copy; H

Joan Go-sechi Emaki (November Festival at the Imperial Palace in the Joan Era); copy; H

f) Realistic Painting (*nise-e*)

Zuishin Teiki Emaki (The Imperial Guard Cavalry); monochrome; K

Chuden Gyokai Zukan (Portraits of the Emperor and Courtiers Gathered in the Imperial Palace); monochrome; copy; K

Rekidai Shin'ei Sekkan Daijin Ei (Portraits of Emperors and Ministers); K

Sungyu Emaki (Fine Ox); K

g) Fairy Tales (*otogi-zoshi*)

Fukutomi Zoshi (Story of Fukutomi); M

Harai Tonton Emaki (Tale of Monk Furuba); M

Aki no Yo no Nagamonogatari Emaki (Long Tale of an Autumn Night); M

Ashibiki Emaki (Tale of Ashibiki); M

Tsuchigumo Zoshi (Story of Monstrous Spiders); M

Oeyama Emaki (Death to the Devil of Oeyama); M

Junirui Emaki (Poetry Contest of the Twelve Zodiac Animals); M

II. Sutra Scrolls with Monogatari Elements

Kuno-ji Kyo (Kuno-ji Sutra); H

Hoke-kyo (Lotus Sutra); Chokai Collection version; H

Heike Nokyo (Heike Dedicatory Sutra); H

Semmen Shakyo (Fan-shaped Sutra); H

Ichiji Rendai-kyo (Lotus-decorated Lotus Sutra); H

Menashi-kyo ("Featureless Faces" Sutra); H

III. Religious Themes

a) Sutras and Other Religious Teachings (*kyoten; kyogi*)

Tempyo E Inga-kyo (Tempyo-Era Sutra of Cause and Effect); N

Jigoku Zoshi (Scroll of Hell); H

Gaki Zoshi (Scroll of Hungry Ghosts); H

Yamai Zoshi (Scroll of Diseases and Deformities); H

Kegon Gojugo-sho Emaki (Zenzai Doji's Pilgrimage to the Fifty-five Saints); K

Juni Innen Emaki (Scroll of the Twelve Fates); K

E Inga-kyo (Sutra of Cause and Effect); K; SSN

b) Chronicles of Religious Founders (*shumon soshi no denki*)

Kegon Engi Emaki (Legends of the Kegon Sect); K

Genjo Sanzo Emaki (Travels of Genjo Sanzo to

India; also known as *Hosso Hiji Emaki*);
K

Ippen Hijiri Emaki (Biography of Saint Ippen);
Kankiko-ji version; K

Ippen Shonin Eden (Pictorial Biography of Saint
Ippen); Fujisawa version; K; SSN

Honen Shonin Gyojo (Biography of Saint
Honen); K; SSN

Shui Kotoku-den (Biographies of Saints Honen
and Shinran); K

Shinran-den Emaki (Life of Saint Shinran); K;
SSN

Ganjin Toseiden (The Eastern Journeys of
Priest Ganjin); K

Kobo Daishi Eden (Biography of Priest Kobo
Daishi); K; SSN

Jodo Goso Eden (Lives of the Five Founders of
the Pure Land Sect); K

Shotoku Taishi Eden (Pictorial Biography of
Shotoku Taishi); K; SSN

Boki Emaki (Life of Priest Kakunyo); M

Yuzu Nembutsu Engi (Legends of the Yuzu
Sect); M; SSN

c) Legendary Histories and Miraculous Tales of
Shrines and Temples (*jisha no engi; reigen
ki*)

Kokawa-dera Engi (Legends of Kokawa-dera);
H

Kitano Tenjin Engi (Legends of Kitano Tenjin
Shrine); K; SSN

Matsuzaki Tenjin Engi (Legends of Matsuzaki
Tenjin Shrine); K

Egara Tenjin Engi (Legends of Egara Tenjin
Shrine); K

Kasuga Gongen Kenki (The Kasuga Gongen
Miracles); K

Ishiyama-dera Engi (Legends of Ishiyama-
dera); K

Taima Mandara Engi (Legends of the Taima
Mandala); K

Yata Jizo Engi (Legends of Yata Jizo); K

Jizo Engi (Legends of Jizo); K to M; SSN

Nakifudo Engi (The Compassionate Fudo
Myo-o); M

Sanno Reigen Ki (Miraculous Tales of Sanno
Shrine); M; SSN

Jingu Kogo Engi (Deeds of Empress Jingu); M

Kiyomizu-dera Engi (Legends of Kiyomizu-
dera; also known as *Seisui-ji Engi*); M

Seiko-ji Engi (Legends of Seiko-ji); M

Inaba-do Engi (Legends of Inaba-do); M

Shinnyo-do Engi (Legends of Shinnyo-do); M

d) Quasi-Religious Works (*shukyo kankei*)

Choju Jimbutsu Giga (Scroll of Frolicking Ani-
mals and People); monochrome; H

Tengu Zoshi (Stories of Conceited Priests); K

TITLES IN THE SERIES

Although the individual books in the series are designed as self-contained units, so that readers may choose subjects according to their personal interests, the series itself constitutes a full survey of Japanese art and will be of increasing reference value as it progresses. The following titles are listed in the same order, roughly chronological, as those of the original Japanese editions. Those marked with an asterisk (*) have already been published or will appear shortly. It is planned to publish the remaining titles at about the rate of eight a year, so that the English-language series will be complete in 1975.